GRAPHISCAPE
NEW YORK CITY

Published and distributed by RotoVision SA
Route Suisse 9
CH-1295 Mies
Switzerland

RotoVision SA, Sales & Production Office
Sheridan House, 112/116A Western Road
Hove, East Sussex BN3 1DD, UK

Tel: +44 (0)1273 72 72 68
Fax: +44 (0)1273 72 72 69
E-mail: sales@rotovision.com
www.rotovision.com

The typeface used throughout this volume is Tarzana Narrow (Emigre),
designed by Zuzana Licko, circa 1998.

10 9 8 7 6 5 4 3 2 1

ISBN 2-88046-767-5

Manufactured in China by Everbest Printing Co., Ltd.

GRAPHISCAPE
NEW YORK CITY

Ivan Vartanian Lesley A. Martin

RotoVision

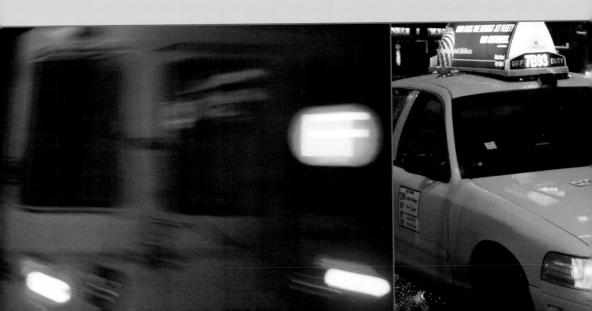

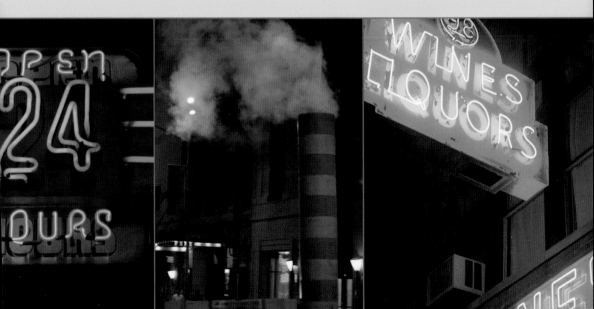

THE CITY THAT NEVER SLEEPS

Each volume of the GRAPHISCAPE series is a total profile of one city's graphic landscape. The unique rhythm harmony of graphic elements that help define a city's vibe also give it a characteristic energy, setting it apa from all other locales. The series kicks off with New York City—undoubtedly the epitome of the urban and the m for countless artists, businessmen, and immigrants alike. So what makes it the city that never sleeps, the Bi, Apple, and the city of ambition? It is a veritable Coliseum holding countless dramas—both on and off stage!

The people, the sounds, and the smells of a city are essential components of its identity, but all of these item must find a physical home for themselves, a means of organization that is visual and spatial. Walk through th streets of the city and train your eye on these elements: the bright and bold billboards of Times Square, the tid waves of traffic, the flash of yellow cabs and red brake lights in the street; the architectural collisions of brownst against green glass walls and modernist concrete, the yellow florescent warmth of underground lights reflected in gleaming subway cars. Pay close attention and the city starts to unfold, revealing detail, texture, and intersectin lines that accumulate into identity. The ebb and flow of history, industry, and economy has left behind a collc of styles and artifacts in competition for your attention.

The GRAPHISCAPE series launches at a time when it is easy to suspect that globalization has done away wi any large city's unique sense of self—that all city centers have become mere amusement parks with chains an franchises serving as the carnival rides. GRAPHISCAPE aims instead, to catalog a wide-ranging mosaic of elemer that coalesce into uniqueness in the world's cultural capitals.

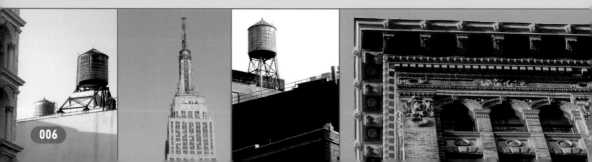

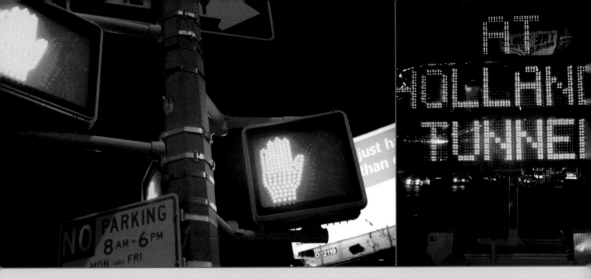

 divided the book into five sections, presenting the over-arching themes: City State, Post No Bills, Hold the
, Signage, Big City Bright Lights. With the first section we look at the infrastructure of the city, including the
us municipal systems that keep the city functioning and orderly—the transit, water, and sewer systems, the
 e and fire departments—and the graphics that developed in response to the 9/11 attacks. In the next we
de graphics that are a toss-up between offense against the law and art—graffiti. Following this is the section
od. The proverbial ham sandwich is a staple luncheon meal. But the diversity of ethnicities in this city makes a wide
ty of foods and tastes available to New Yorkers. The immigrant communities that form in different sections
e city create enclaves of specific cuisines.
rue to the reality of living in this city, most of the inspirational graphic material collected in this volume is
ymous and intended for the most practical of purposes. You will never—or at least very rarely—know who
ed those beautiful architectural rosettes or forged that brass art deco signage. The overall style will have
ct, but the artist remains anonymous. The individuals who create neon in the shape of a delicate hand, a
licated Chinese character, or an oversized hot-dog sign imploring you to EAT it are the artisans of today.
book is dedicated to them and their anonymous impact on the larger system of graphics, lifestyle, and how
xperience the world around us.

CITY STATE

New York City has always been a world unto itself. As a now iconic cover illustration for the *The New Yorker* sums up: "There's Manhattan and then there's the rest of the world." Certainly, this is part and parcel of the self-inflated no that NYC is the capital of the world. But with its strong status as the world's premier city, cultural hub, and busines center, it's an understandable character flaw for this city of ambition. The scope of disparate activity in the city is a perfectly inverse ratio to proximity. The sleeze of Times Square is just kitty-corner from Broadway theaters. You c pretty much reach out and touch the financial district with your chopsticks when you're in Chinatown. And the Cent Park Zoo's rainforest is just minutes from the Metropolitan Museum of Art. Within this dense matrix of space and activ the city requires a finely tuned infrastructure to keep it all running like clockwork, or faster when you take into consideration the New York minute.

How does a city of such diversity and bustle build a graphic identity from so many disparate pieces? What are th elements that comprise this mosaic? Because such a lot is contained in such a geographically small city, there is qu a bit compacted, making organization all the more a prime issue. Clearly, before the city came into its own there w little to suggest that it would thrive to the extent it has, nearly faltering under the weight of its own success. So the c infrastructure gets updated in small and incremental ways, just as the primary flavors, the palettes, the iconography, the textures are in continual flux. With each new wave of immigration, or each passing trend in the Fashion district Madison Avenue, or each rise of political villain, hero, or celebrity superstar to the top, New York absorbs and enfo the accompanying aesthetic into its fabric. Each adaptation becomes a part of what makes up the vibe of the city, adding a certain tension and complexity. You can never relax for too long. But no matter where you come from, there only so many ways of navigating New York City—cabbing it, subwaying it, or hoofing it—you have to know how to get t from here. Pay attention to those colored dots and green lantern lights and oh-so-mundane underground signs poin you this way and that way. Learn to trust the spaghetti of subway and bus lines as they appear on the municipal sig It may not be an exact grid, but it is a grid that helps. Sometimes, it's the only constant you've got.

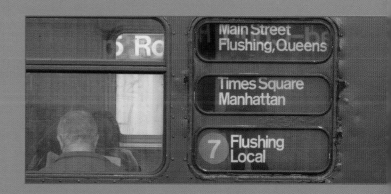

9/11 Indescribably shocking and world-changing, the attacks that felled the World Trade Center brought New Yor onto television sets and into minds around the globe. On the Manhattan streets, a new iconography was born, pairi trauma with pride, despair with perseverance, heroism with terror. Memorials took place on the city sidewalks and walls, with mass-produced flyers, hand-scribbled messages, and highlighted names enshrined in public places, allow a public venting of longing, loss, and frustration. A new patriotism came to infuse the imagery in community mural and local advertising. Above it all, the image of the Twin Towers, stylized and repeated many times over, has becom an inviolable symbol of what was, and of the hopes for a new, rebuilt future.

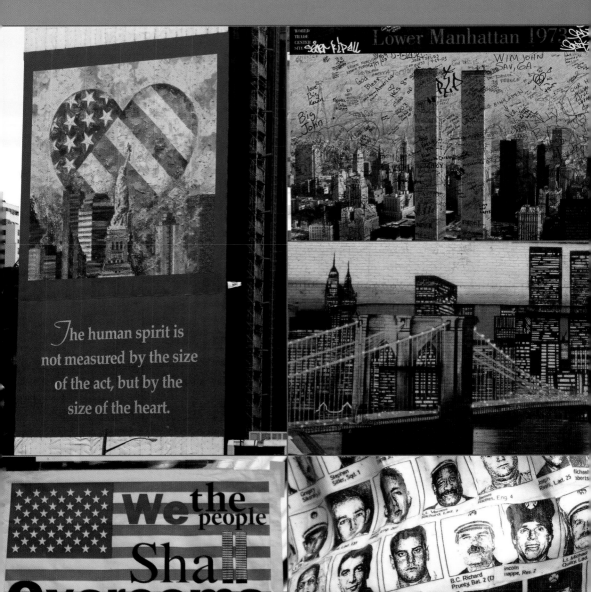

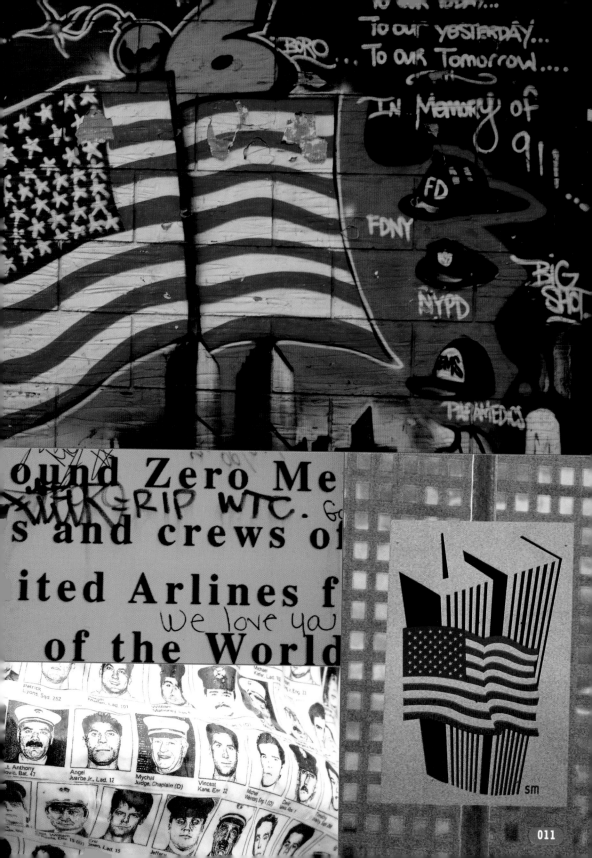

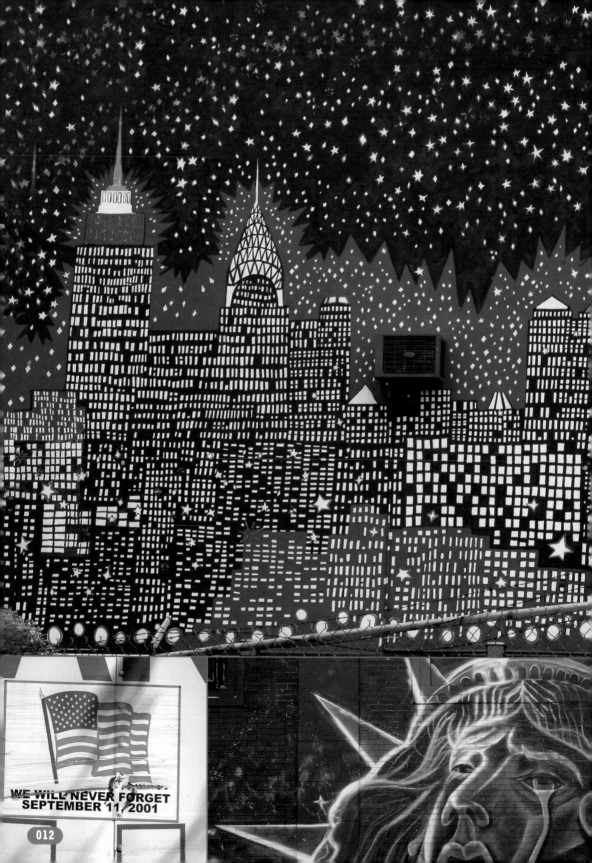

WE WILL NEVER FORGET
SEPTEMBER 11, 2001

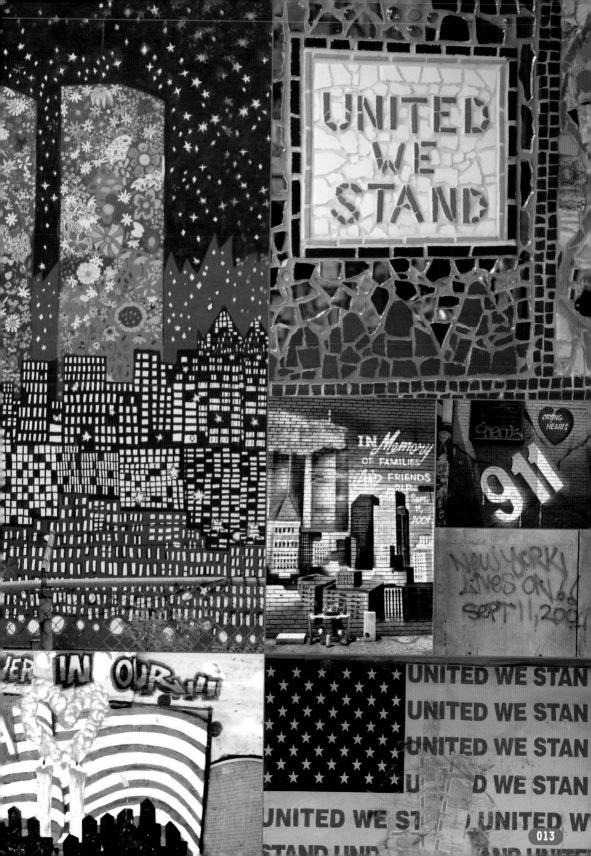

UNITED
WE
STAND

IN *Memory*
OF FAMILIES
AND FRIENDS
R.I.P.
Sept.
11,
2001

CRYING
HEARTS

911

NewYork
Lives on
Sept 11, 200

IN OUR

UNITED WE STAN

UNITED WE STAN

UNITED WE STAN

U D WE STAN

UNITED WE ST UNITED W

STAND

013

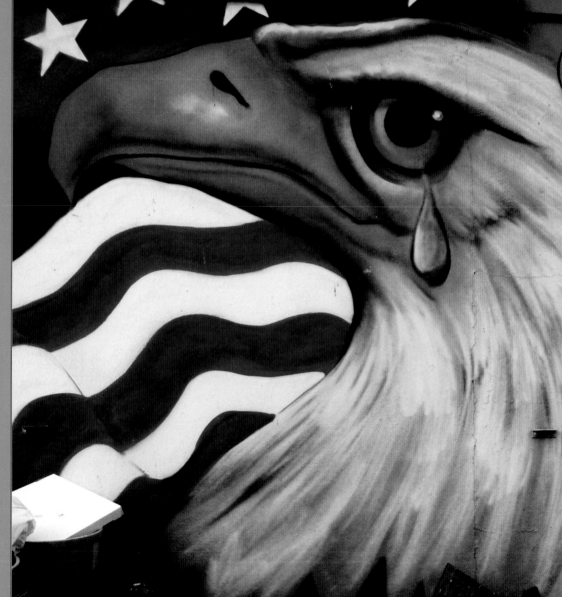

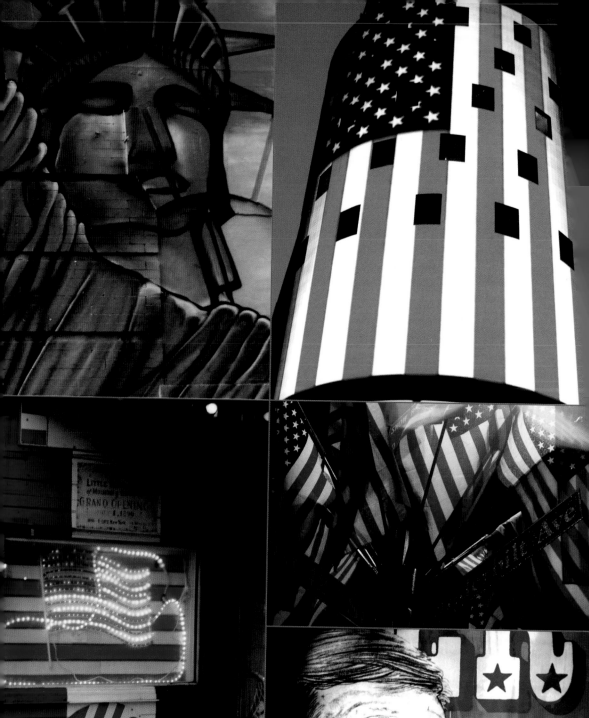

DOPE IS
FOR DOPES
DON'T BE
A DOPE!

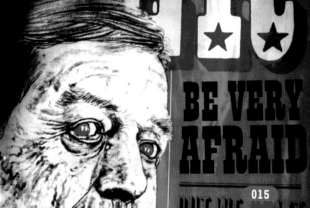

BE VERY
AFRAID

I ♥ NY This has become THE warm and fuzzy signifier of this Big Ol' Apple, and despite its ubiquity, make no mistake about it, this oft-imitated logo is owned by the Department of Economic Development of the State of New York. It was designed by logo-genius Milton Glaser in 1976, a time when the state and city's reputation as a den of thieves and infidels did little to attract investment and bolster local economy. A red heart was used in the slogan and a theme song was drummed up using the same catch copy, giving the impression that stern New Yorkers were, at heart, ready to leap into song, not unlike a Broadway musical. This campaign has been reborn post 9/11 as "I ♥ NY MORE THAN EVER" with much the same intent. Simple, clean, we ♥ it so.

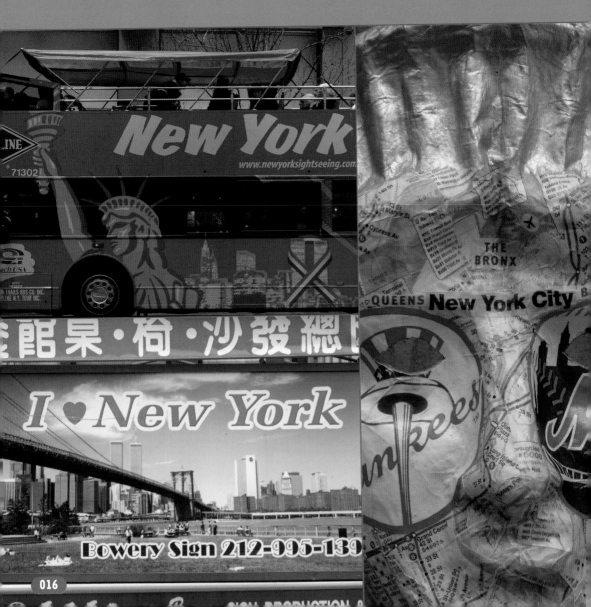

Bowery Sign 212-995-139

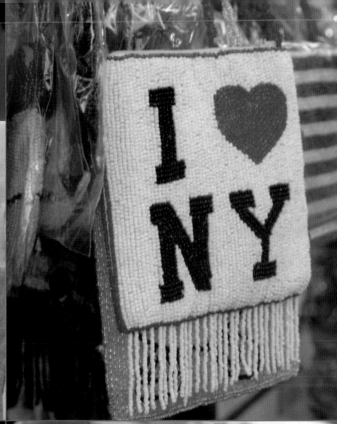

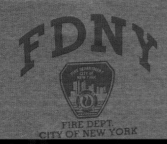

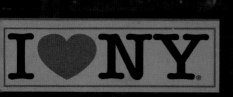

POLITICAL DISSENT With the world's attention focused on New York City, and despite the brisk sales in flags and other patriotic pins, the city held true to its reputation as willing to lend a critical viewpoint. The streets also became the forum for expressions of dissent. With the rest of the country poised for war, a large number of New Yorkers voice a plea for peace. Caricatures of the president and clear messages of disapproval for the administration's eagerness to wage war were literally plastered all over the city, making clear the message of dissent.

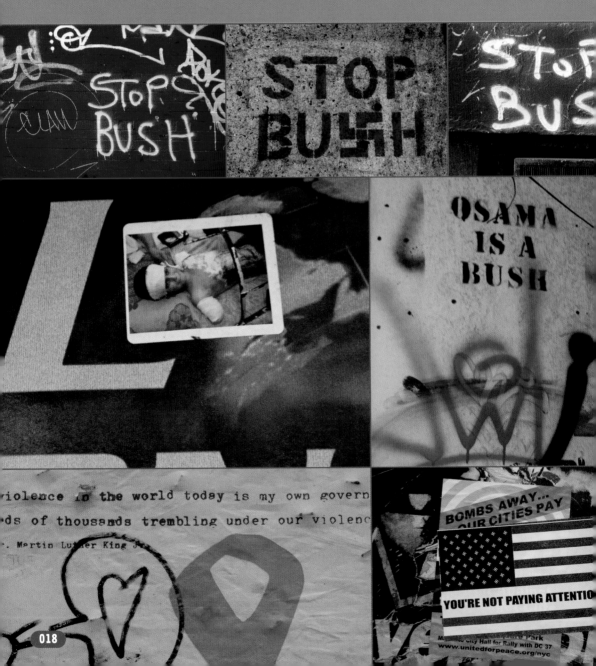

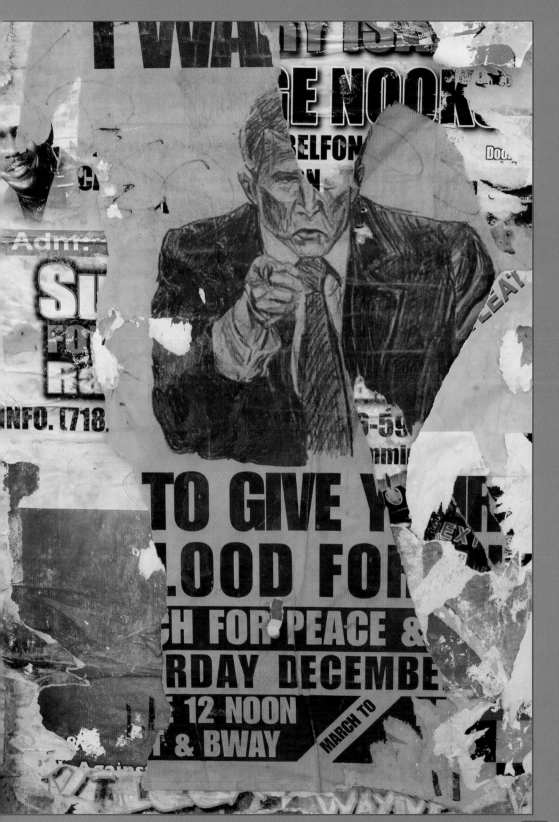

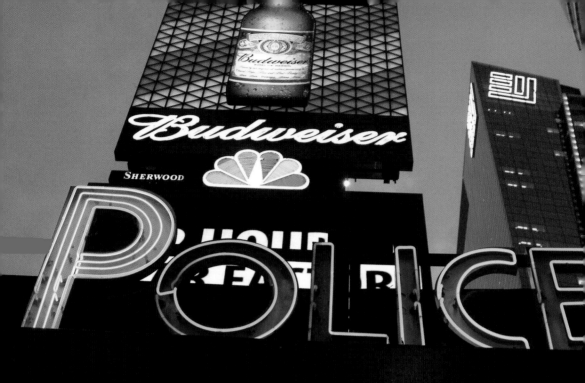

Budweiser

SHERWOOD

POLICE

DO NOT CROSS

DO NOT

POLICE DEPT.

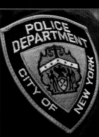

POLICE DEPARTMENT CITY OF NEW YORK

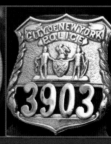

CITY OF NEW YORK POLICE

3903

COURTESY
PROFESSION.
RESPECT

3 T R U C K

F D N Y

B A T T. 6

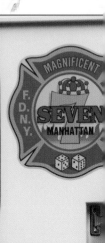

F.D.N.Y. MAGNIFICENT **SEVEN** MANHATTAN

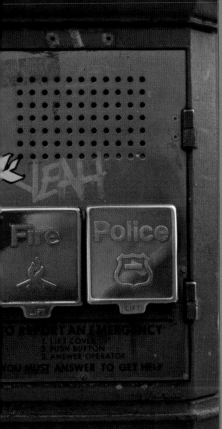

MEN IN RED AND BLUE The blip of a squad car and the low, cruising ring of a fire engine siren are unmistakable elements of the city's night soundscape. Both of these forces have enjoyed a renaissance in reputation and esteem since 9/11. The design of a police patrolman's badge (a shield) hasn't changed since 1902; the patches have gone through several revisions and have many designs. There are some 28 different insignia distinguishing officers, detectives, traffic police, and auxiliary police, for example. The fire department has a history that reaches back to the city's days as a Dutch settlement. Early fire departments were little more than organized street gangs and a path to a political career. Today each station has its own nickname and corresponding logo. The distinctive badge of the NYFD still proudly features the Twin Towers, retained in memory of those who lost their lives on duty during their demise.

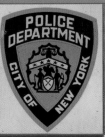

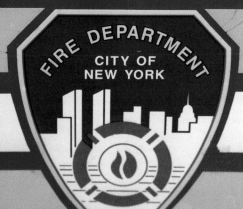

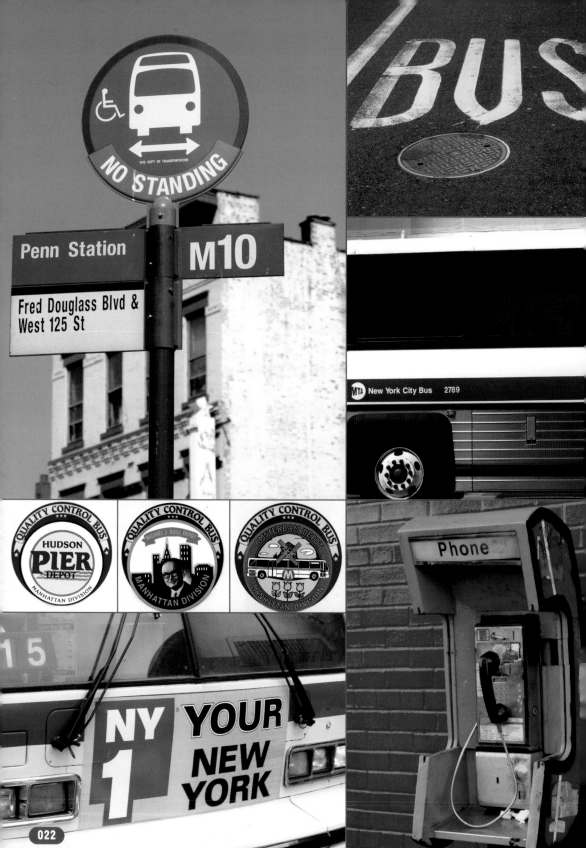

Central Pk West

SI-1105M DEPARTMENT OF TRANSPORTATION

GREAT LAWN

GETTING AROUND Everybody is in a B-I-G rush to get *somewhere*, and fast, in New York City. Where to go, how to get there ... what was that last stop? All these questions are answered by the thoughtful people at the New York City Department of Transportation (DOT). The work that they do is not too fancy, but a little creative iconography and some basic fonts, and you know just where you are in the city. In addition to making signs, the DOT manages the city streets, sidewalks, streetlights, and parking meters, and repairs potholes. It's a big, thankless job, but they still have time to put a few flourishes into the mix.

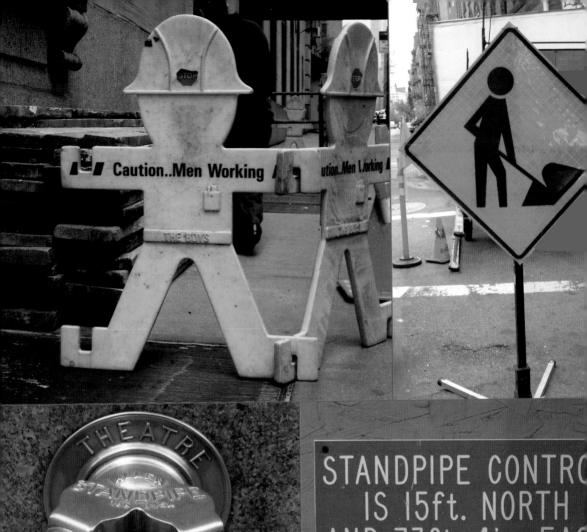

Caution..Men Working

Caution..Men Working

THE BOYS

STANDPIPE CONTRO
IS 15ft. NORTH
AND 73ft. 4in. EAS
OF THIS SIGN

THEATRE

STANDPIPE

N Y C SEWER

N Y C
ELECTRICA

GETTING DOWN There are countless urban legends, most of which are pure, unsubstantiated myth. One such is that alligators lurk below the streets of the city, the sewer system their new habitat. An added twist is that the 'gators are albino, having lost their natural color after so long in the dark recesses. Paranoid New Yorkers certainly have nothing to fear—about the only thing dangerous down below is bacteria. And if anything did try to escape, it would be blocked by the hefty manhole covers. These heavy metal discs are industrial artifacts, with an array of patterns and signature markings. Their designs seem as varied as their number. The early metal foundries of NYC were essential contributors to the city's growth and these relics bespeak the achievement of a forgotten industry that helped to raise the city. (These days, they are mostly made in India.)

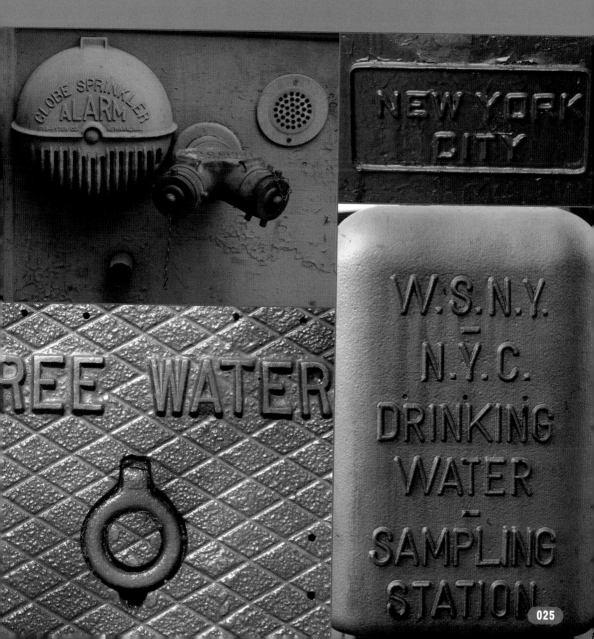

IT'S THE LAW
clean up
after
your
dog
maximum
fine $1000
public health law 1310

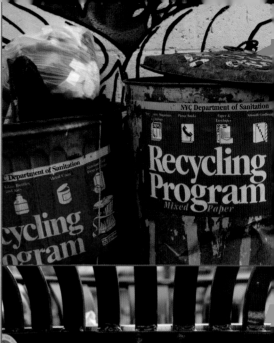

NYC Department of Sanitation

Recycling
Program
Mixed Paper

Department of Sanitation

cycling
rogram

Keep New York City

Keep New York City Clean

Don't
Litter
Put It

1625

CITY OF NEW YORK

FOR OFFICIAL USE O

EXTRA EXTRA Sure, *The New York Times* is pretty much the dominant paper, but New York City newspapers and tabloids cater to a range of viewpoints and to a diversity of demographics. They include the *Chinese United Journal*, *Forward*, *Irish Echo*, *Jewish Post*, *India in New York*, and *El Diario*, to name a few of the dozens of local papers. Several are indispensable resources for the low-down on cultural events and happenings. This is especially true of community events.

.00 DAILY
.00 SUNDAY

USE ANY COMBINATION
OF NICKELS,
DIMES OR QUARTERS
DO NOT USE PENNIES

The New York Times

229 W. 43rd St., New York, NY 10036

Call: 1-800-354-6450 to report problems
COIN ↕ RETURN

DRIVEN TO GIVE YOU
M⊙RE!
DAILY ⊙ NEWS
ON SALE HERE

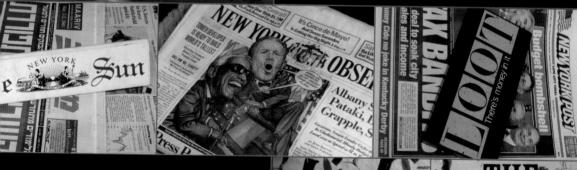

New York **Sun**

EWSSTAND

THE
NEW YORK
OBSERVER

027

YELLOW CABS The familiar flash of taxi-cab yellow should be enough to keep you on your toes... An alternative to the subway, taxi cabs are a quicker way of getting around town. But maybe too quick at times. Pedestrians need to keep on their toes as they often barrel down the streets at NASCAR (National Association for Stock Car Racing) speed despite apparent traffic congestion. Flagging down a cab can have you jumping back a few feet. But on rainy days when cabs are returning to their depot, it requires a degree of luck to nab one of the over 10,000 cabs working the c

PLEASE HAVE
FARE READY
WHEN REACHING
DESTINATION

TAXI FARE
$2 00 Initial Charge
30¢ Per 1/5 Mile
20¢ Per Minute Stopped
or Slow Traffic
50¢ Night Surcharge

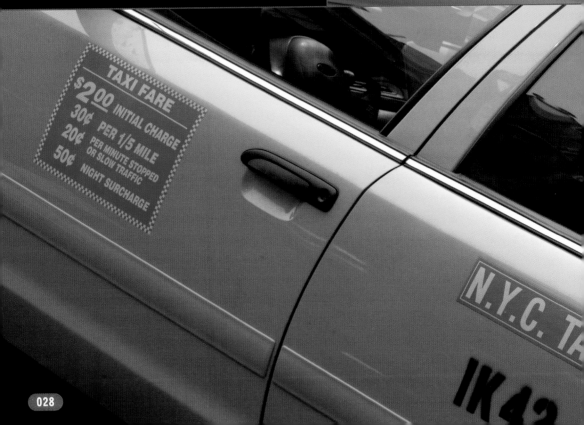

TAXI FARE
$2 00 INITIAL CHARGE
30¢ PER 1/5 MILE
20¢ PER MINUTE STOPPED
OR SLOW TRAFFIC
50¢ NIGHT SURCHARGE

N.Y.C. TA

IK 42

ery day. Plus, every true New Yorker knows how to steal a cab from someone else trying to hail one just a few feet
ay. There are no apologies in the game of getting there in a New York minute. Yellow Medallion cabs are the only
es authorized to pick up hails; livery or "gypsy" cabs are not. The famous "checker" cabs have almost disappeared;
en they are spotted they charge limousine service rates.

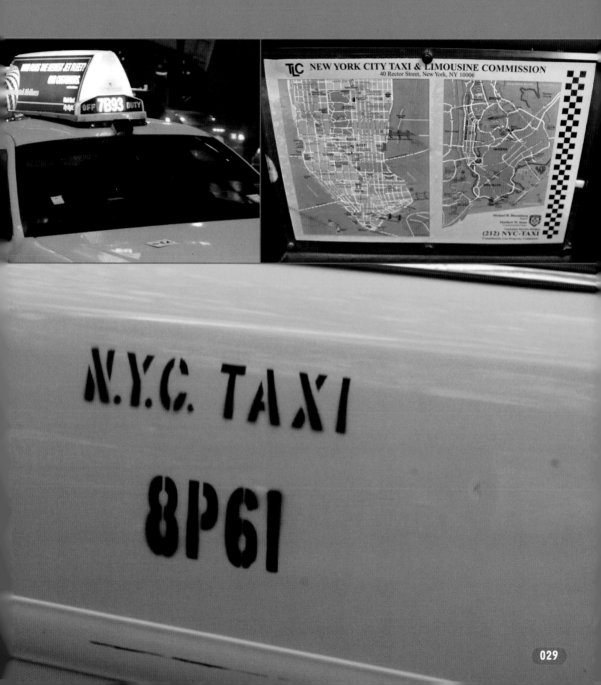

8N81 COMPLAINTS 212 NYC TA

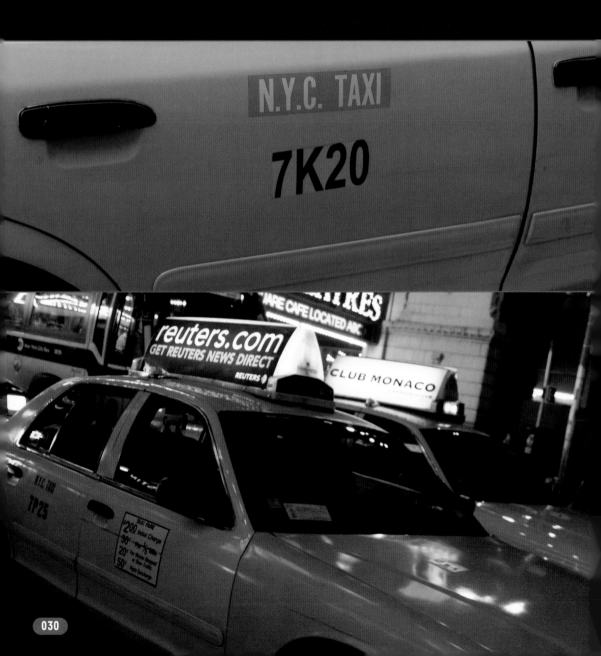

OFF DUTY **SN36** OFF DUTY

Taxi Fare from JFK Airport
to any destination
in MANHATTAN

$35 FLAT FARE
(Does not include toll or tip)

TLC NEW YORK CITY
TAXI & LIMOUSINE
COMMISSION

40 Rector Street
New York, NY 10006

Rudolph W. Giuliani, Mayor
Matthew W. Daus, Commissioner/Chair

24-Hour TLC Consumer Hotline
Call (212) NYC-TAXI

4 L 28 COMPLAINTS 212 NY

The New York City Taxi P

The New York
Public Library

of A...
...ew Yor...
...he Met...
Museu...
of Art...

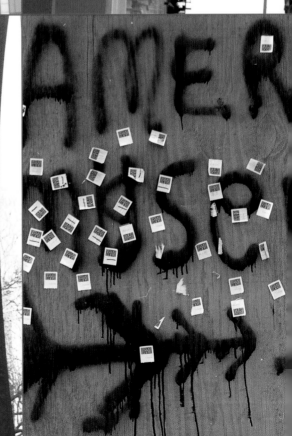

The Metropolitan
Opera

2002–2003 Season
September 23 – May 3

All Performances with Met Titles
(212) 362-6000
www.metopera.org

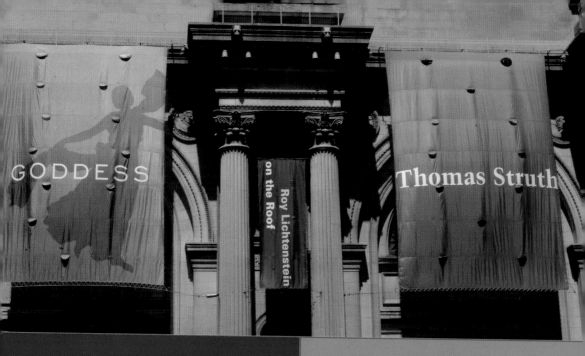

GODDESS

Roy Lichtenstein
on the Roof

Thomas Struth

MoMAQNS
Museum of Modern Art, Queens

P.S.1
INSTITUTE FOR CONTEMPORARY ART

AMERICAN MUSEUM OF
NATURAL HISTORY

CULTURAL SIGNPOSTS Museums and other cultural institutions are an industry unto themselves within the commerce of the city. With museum attendance not only up on, but skyrocketing beyond averages of the recent past, the city has become a widely used cultural venue, drawing in droves. As cultural institutions everywhere learn and reap the benefits of image and branding, the graphics that adorn their facades become significant aspects of their identity, parlaying their collections into high-end brands themselves. The accumulation of art and artifacts throughout the city is phenomenal, with little indication of losing momentum. The American Museum of Natural History can have you dwarfed by a great blue whale or dinosaur; the Intrepid Sea-Air-Space Museum gets you on the decks of an actual carrier.

THE MTA Every line in the transit system has a considerable degree of art. To promote use and enhance travel time, the transit authority has sponsored the creation of murals to be installed on station walls throughout the city. A glass mosaic at the 59th Street-Lexington Avenue subway, by artist Elizabeth Murray, is just one example from hundreds of commissioned artists. Entitled *Blooming* (1996–1998), it is a "dreamy underworld" of oversize coffee cups and a fantasia of swirling plumes of color. The 81st Street Natural History Museum has some of the more spectacular murals, turning the station into an underwater diorama. A shark is about to attack and a snail races to catch the train. The otherwise dreary commute becomes an opportunity for daydreaming. One of the largest in the world, the New York City Transit subway system runs 24 hours and carries millions of people every day! The infrastructure, including the information system used by travelers to negotiate the maze of transfers, corridors, and exits, is equally impressive. The signposts are set in white, bolded Helvetica lettering on a black background. A rule running horizontally above the lettering is common but not always used. The trains themselves are now coded by color along with a number or single letter. This is a fusion of the old system of identification under which three separate subway systems, now integrated into a single transit system, functioned independently of one another.

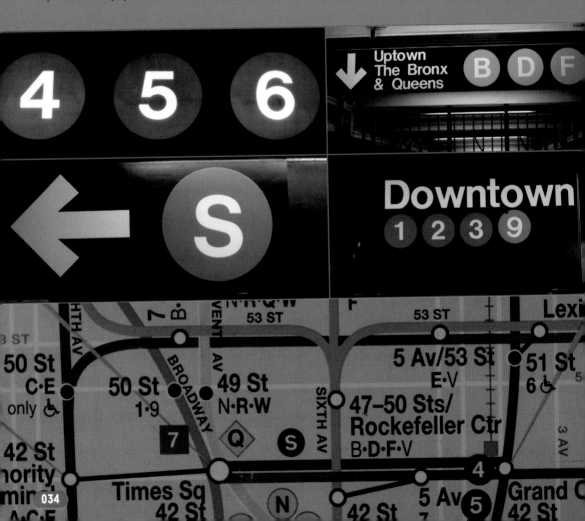

Columbus Circle
59 Street Station
A C B D 1 9

MetroCard required at all times.

Open:	Other times
Daily	enter at 60 St &
5:20am–8:40pm	Central Park W

TIMES SQ.-
42 ST. ① ⑨
UPTOWN &
BRONX LCL.

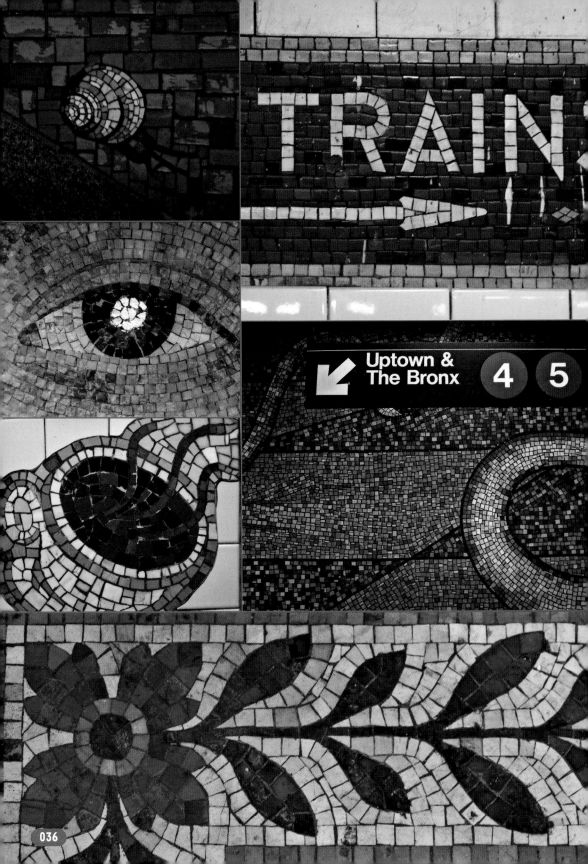

TRAIN

Uptown &
The Bronx 4 5

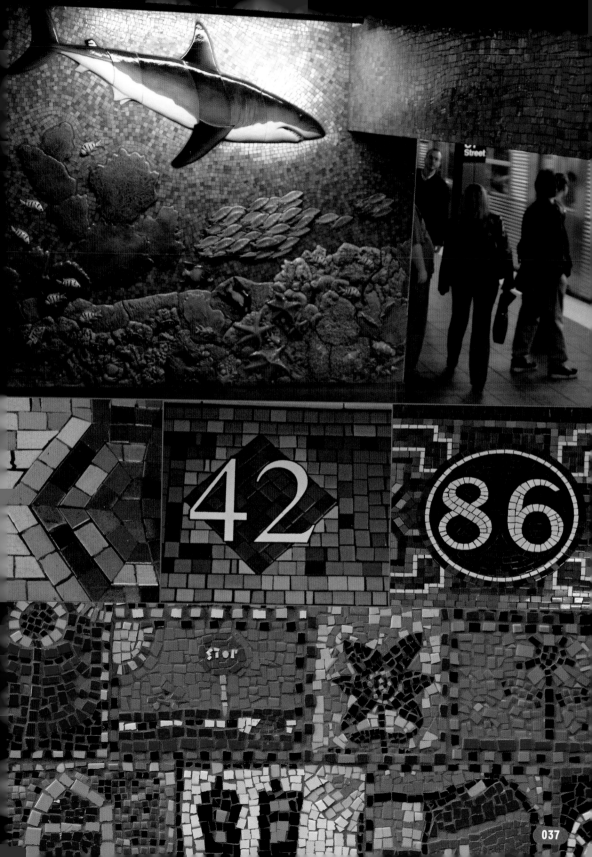

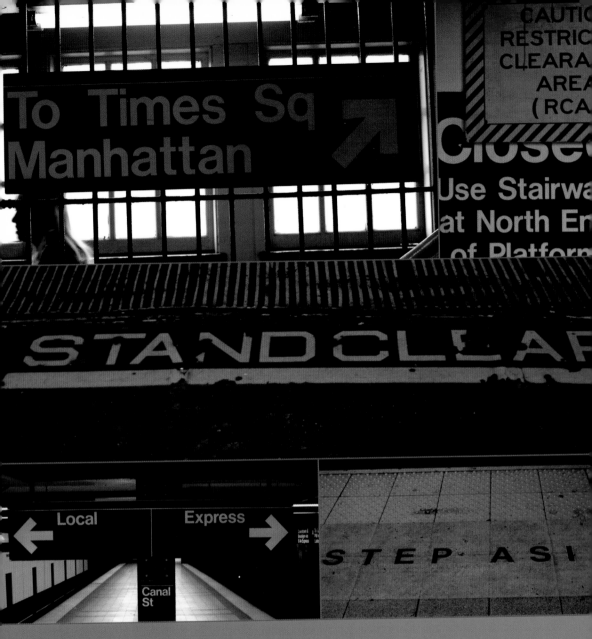

STEP ASIDE I am sure you would *never* lean on the subway doors now would you? But some of the "how-to" and etiquette of subway rides are not so obvious. The simple graphics used to illustrate instructions are an extension the subway's extremely utilitarian design aesthetic and lack any representation of perspective. The graphics are clearly outlined elements with smoothed-out contours—wholly functional, nothing fancy. Unlike some metro system that have fares based on distance, a single fare in NYC will take you from Coney Island all the way to the heart of Bronx. When first introduced, the MetroCard didn't enjoy a great deal of popularity. This debit card slowly phased the use of tokens, which were rendered obsolete in 2003.

nditioned Car
ose windows

Emergency Brake
Open cover
Alarm will sound
Pull handle

2

ot lean on door

se

1680

Evacuation Instructions

Listen for instructions from crew	Do not pull Emergency Brake	Remain inside train. Subway tracks are dangerous	Exit only when directed

1780

168 Street
Manhattan

Euclid Av
Brooklyn

C 8 Avenue
Fulton St

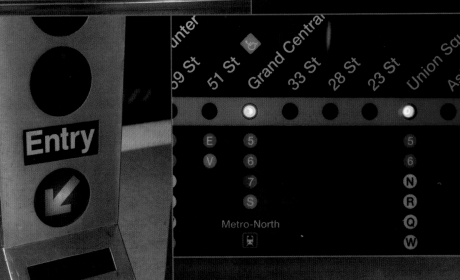

Entry

69 St 51 St Grand Central 33 St 28 St 23 St Union Square Astor Place Bleec

E 5 5 F
V 6 6 V
7 N S
S R transfer
from
Metro-North Q downtown
W trains only

Why wait?

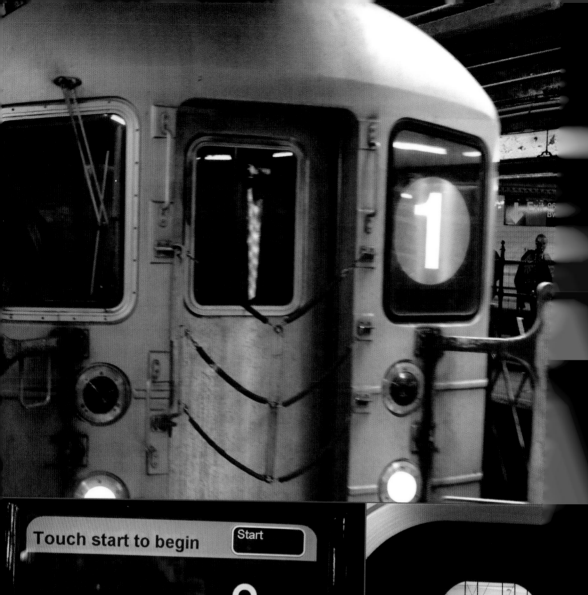

Touch start to begin Start

Touch
Start

SHUTTLE

POST NO BILLS

Keep your ears open in New York City and you will become attuned to a multitude of conversations all around y
It is not just the staccato of any number of languages, the consistent hum of ventilation systems, nor the soft,
rolling sound of fat tires on sun-softened asphalt that will speak to you. You will begin to notice a correspondi
visual symphony raging on the walls around you. This is conversation hashed out in wheat paste and stencils, stic
and spray paint. And don't forget—YOU CAN DO A LOT WITH A MARKER.

This is pattern recognition in the urban environment. Once you become aware of these clusters of poste
murals, and flyers—streetside chat rooms for "Faile," "Basto," and "Porkchop"—it's a thrill to recognize the recurr
cast of characters. Andre the Giant does indeed have a posse: a space invader mosaic peeks out from the side
lower Eastside stoop; the mysterious Styrofoam "mouse blob" appears in alternating, designer-color combinatic
stencils of Bill Murray appear on the bases of light poles.

New York Street Aesthetic is practically synonymous with graffiti and the unique, soft-fuzz quality of the
spray-painted line. OK, sure, technically graffiti is illegal unless it pertains to a community-sanctioned mur
and/or permission is cleared in advance. New York City's Police Department has its own special Anti-Graffiti
Vandal Squad that does battle against the layers of paint, mailing labels, and other forms of "defacement o
public property." Graffiti, of course, has been around for as long as city streets. Since people could write, name
and disses of city personages have been scratched into walls. However, the idea of graffiti as "Art Crime" and t
history of "Aerosol Art" and the other forms it begat, begins simply in the late '60s and early '70s. It begins wi
a bunch of bored, restless kids in the South Bronx intent on spray-painting their names on the surfaces of walls,
trucks, fire hydrants, trains . . . especially trains. The ubiquitous image of New York in the late '70s and early '8
was the subway car covered with graffiti. The styles ranged from basic tags made with a single line of paint t
larger, Wild Style names in neon colors and crazy angular letters. Names like "Stay High" and "Taki 183," or "Amo

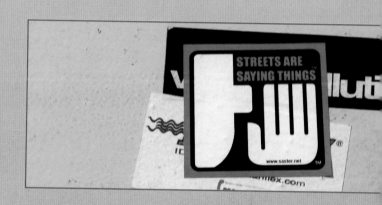

"Dondi" appeared throughout the city. Under Mayor Rudolph Giuliani, the Transit Authority made cracking
n on graffiti a top priority, declaring graffiti to have "an adverse effect on the quality of life in various
munities in the City of New York, creating an impression of disorder and chaos," and "a precursor to more
ous acts of crime and violence." Laws prohibiting the sale of aerosol paint and broad-tipped markers to
r-18s, new paint-resisting materials on subway cars, super-strength "powerwashing vehicles," and renewed
ance has kept the subways fairly clear and clean, with the exception of the irrepressible "scratchitti" or
ed letters scratched into glass and metal surfaces. The art form lives on, however, in street pockets and
havens—including galleries and art museums. Look carefully for the words on the street and you'll see—
STREETS ARE TALKING.

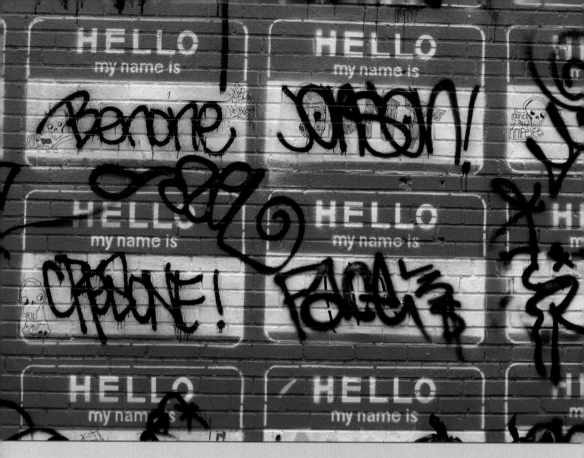

TAGGING Did the creators of the "HELLO, MY NAME IS" label anticipate that their simple, functional introduction h

would be usurped by a generation of graffiti writers worldwide? In the hands of these urban artists, an inherently "unc

item has been given a new purpose and function. A mass-market antidote to anonymity (previously most likely to

seen at mixers or corporate gatherings) has been cross-pollinated with the underdog one-upmanship of tagging.

Tag style has continued to hold firm to its primitive roots, relying equally on stylization of line and letter, and

the extent to which a tag is placed around the city. (Location, location, location!) The layers of aerosol tagging

painted figure combined with black-and-white stencil wield a complicated, aerosol-powered energy... Pastiche-s

tagging notwithstanding, it is still considered disrespectful to go over another writer's work.

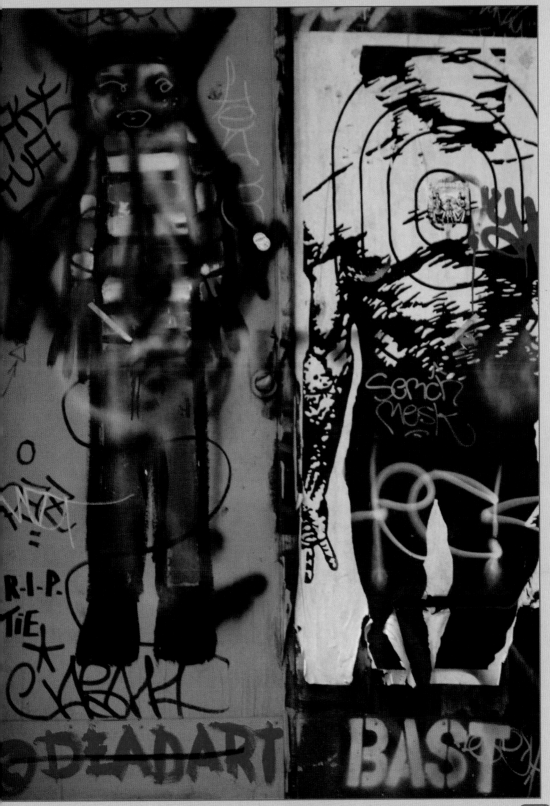

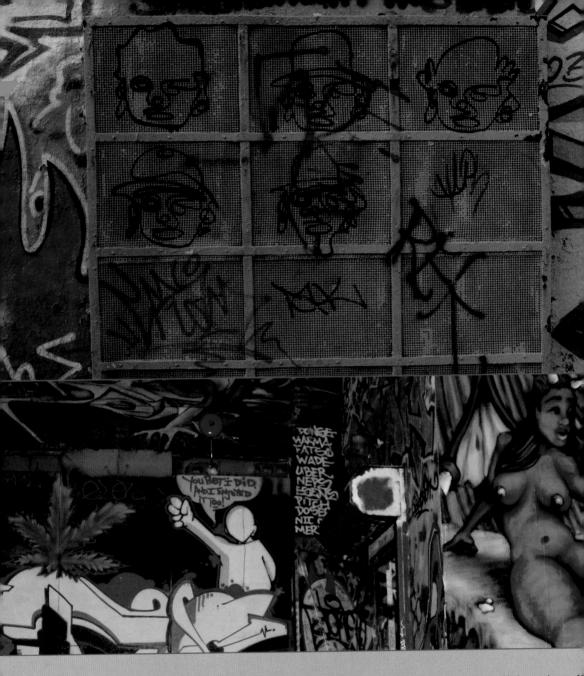

GRAFFITI With subway cars no longer available as art surfaces, thanks to the vigilance of anti-graffiti squads, graffiti writers have taken their art to the streets—and the grates, the stairs, the sides of trucks, walls, ceilings, any surface that doesn't move (and occasionally a few that do). A graffiti name is an urban calling card, a personal logo. Individual names are to be found executed Wild Style (crazily colored, interlocking letters—a style named after an old school from the Bronx) or mixed into mural painting with evocative urban characters—lady demons, subway cars, transformer robots. And all summoned from an aerosol paint can in controlled lines, fades, dots, and drips.

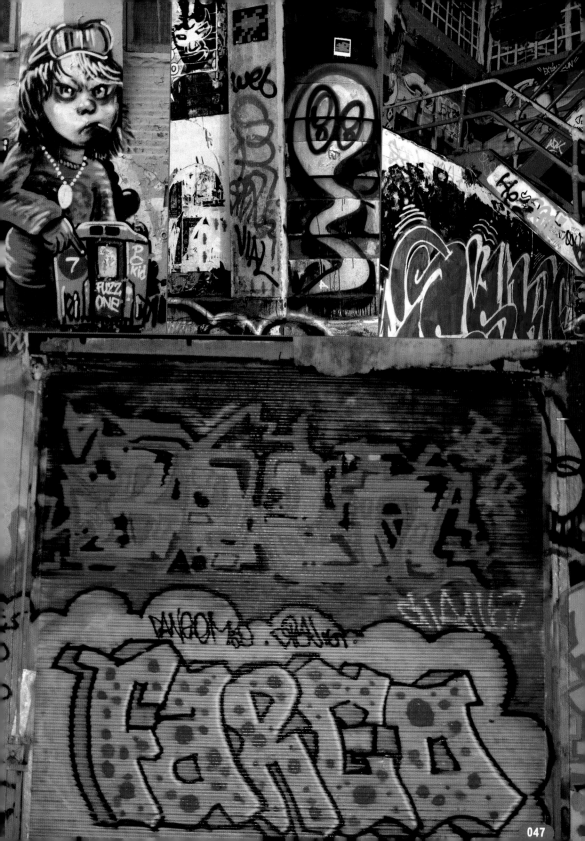

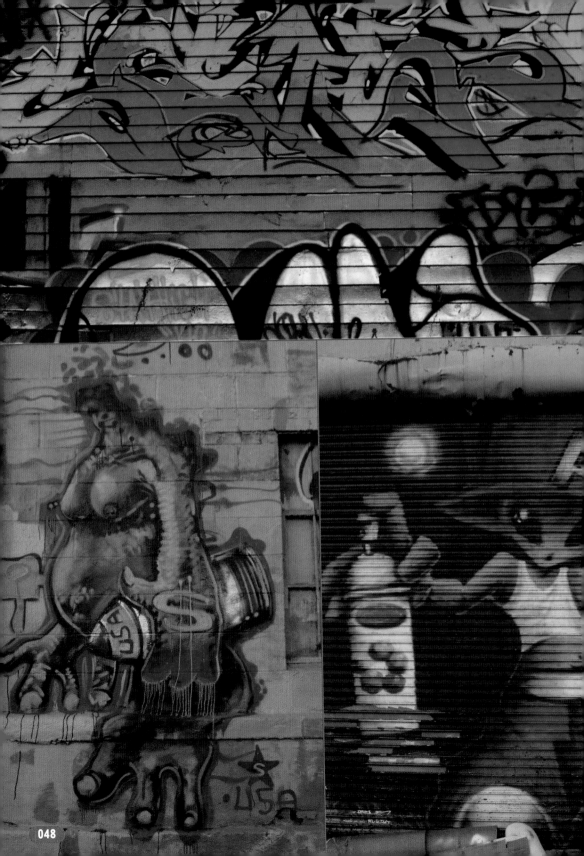

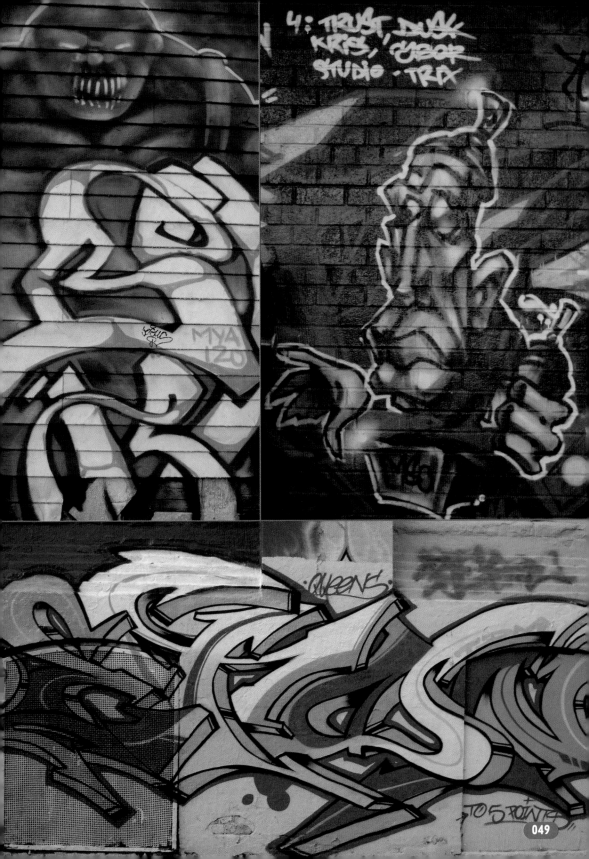

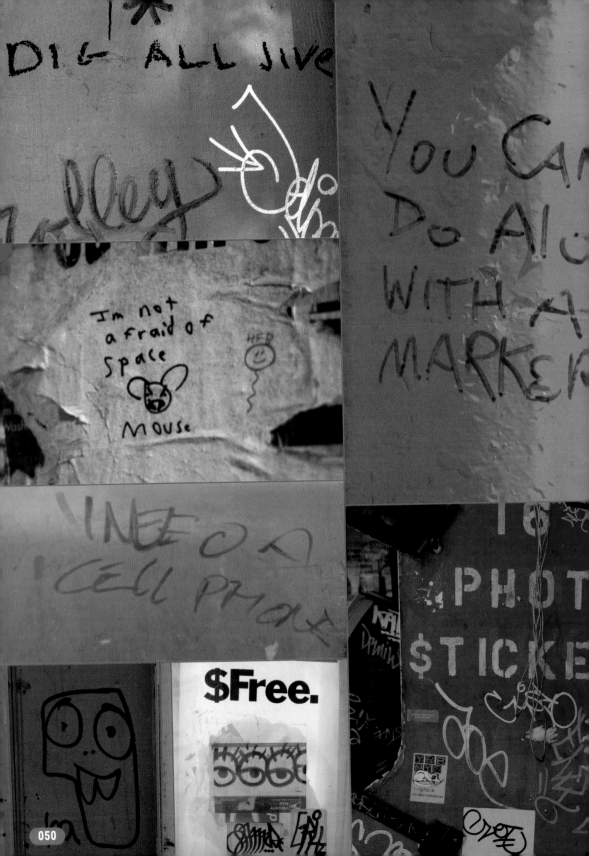

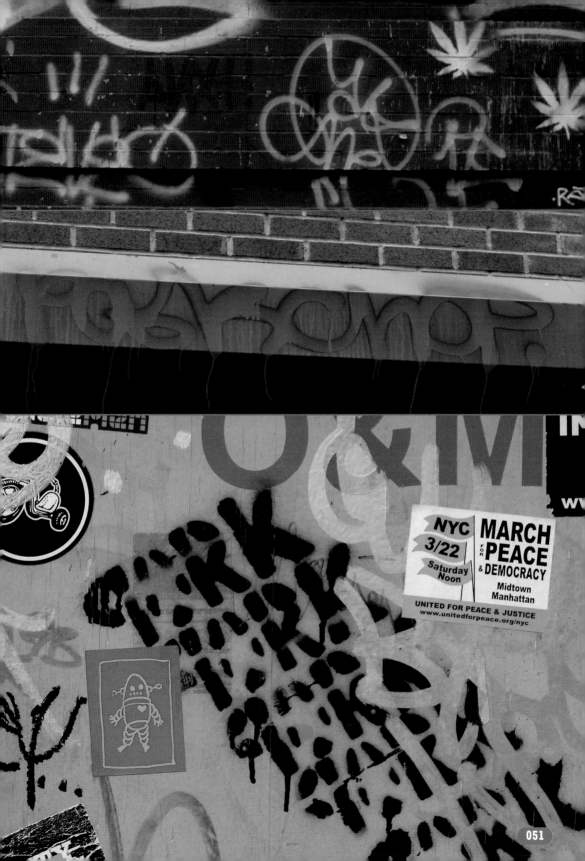

NYC
3/22
Saturday
Noon

MARCH
FOR
PEACE
& DEMOCRACY
Midtown
Manhattan

UNITED FOR PEACE & JUSTICE
www.unitedforpeace.org/nyc

SIGNATURE STYLE Signature tags, incorporating a logo or name, come in a myriad of forms and materials—floa~~
UFO heads; a Space Invader mosaic; odd, Rorschach ink blots of Styrofoam—and range from single, repeated motif~
recognizable styles rendered in stencil or printed and wheat-pasted to walls. The styles of street art, as it starts ~
depart from classic aerosol art, vary wildly, but common features include strong graphic shapes and simple color
palettes (easy and inexpensive for multiples), appropriated imagery, and surprising juxtaposition of elements.

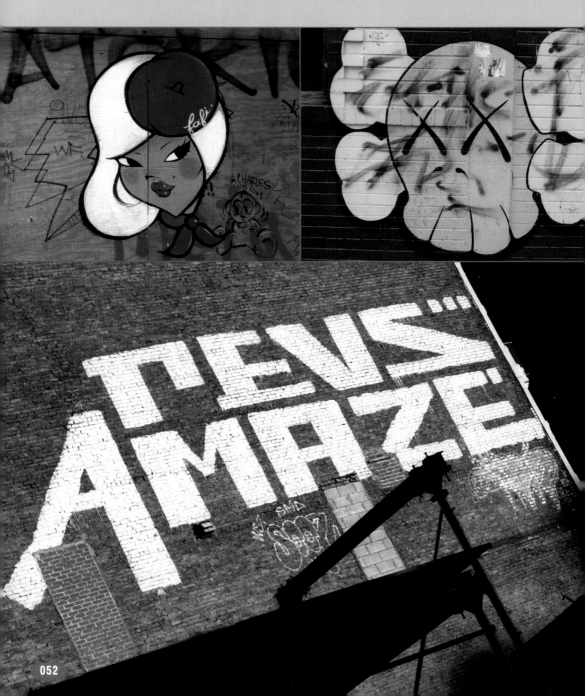

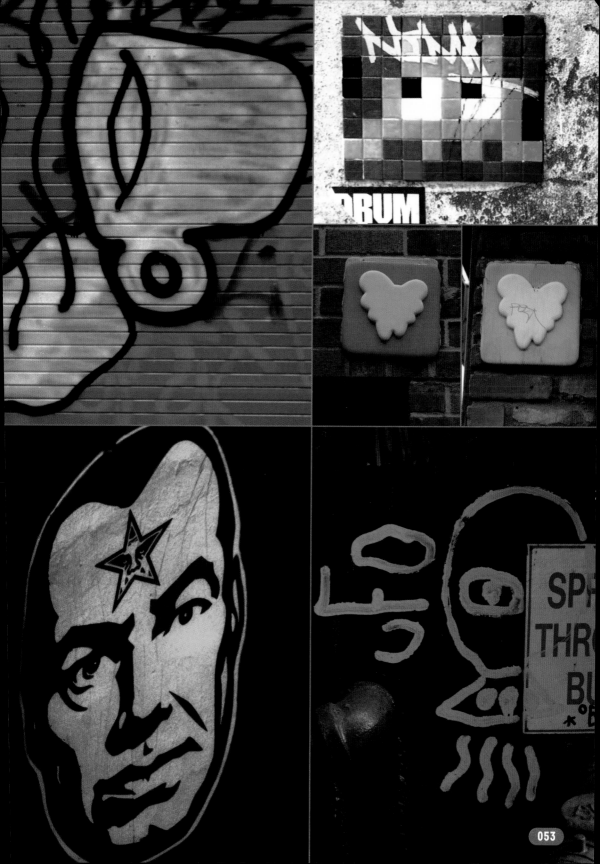

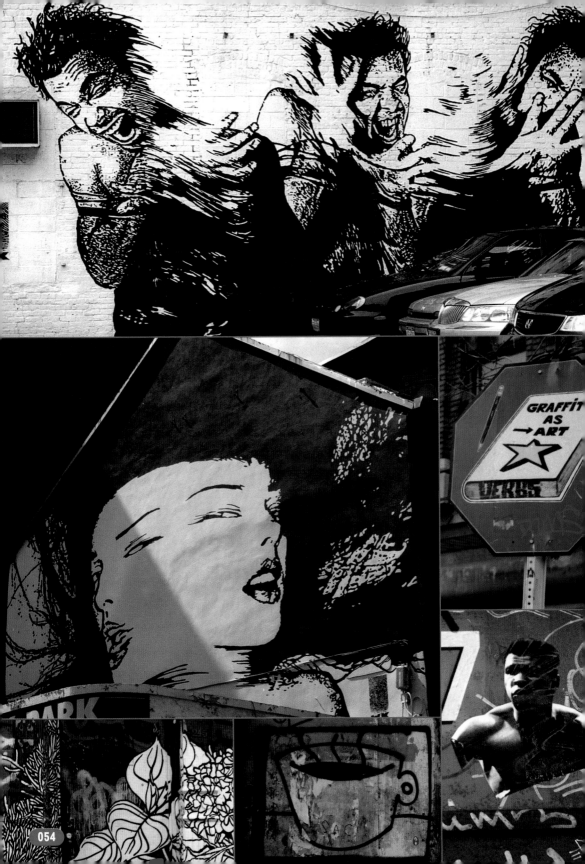

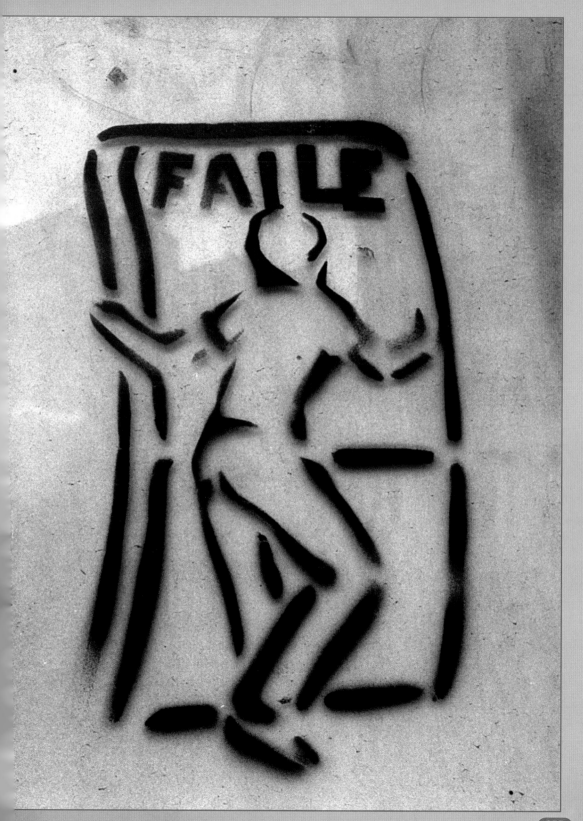

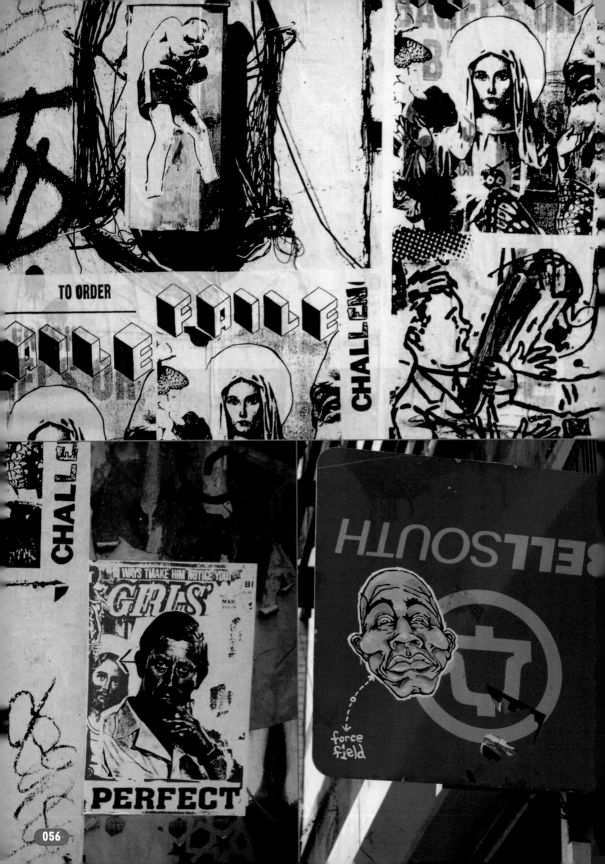

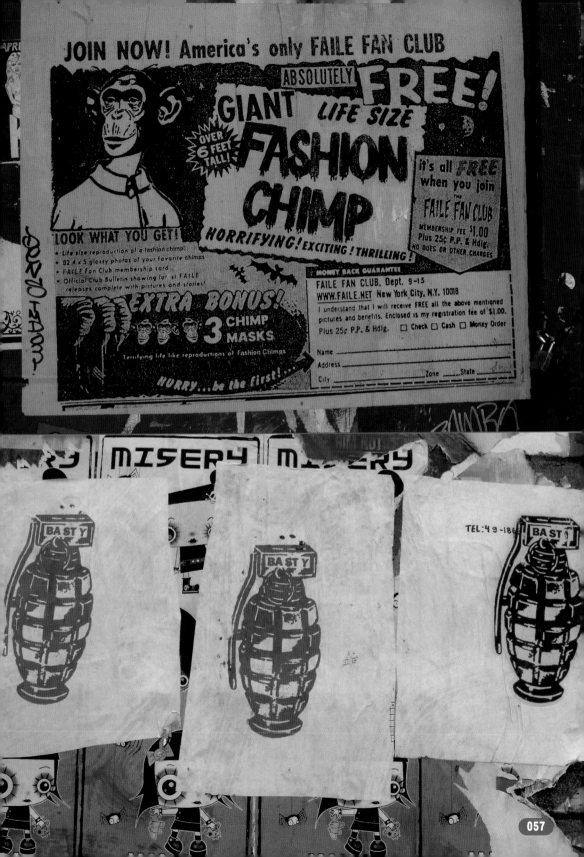

"My work, working with the poor, the desolate, people who really need the help of the worker."

Happiness\Hap"pi*ness\, n [From Happy]
1.Good luck; good fortune; prosperity,
2.An agreeable feeling or condition of the soul arising from good fortune or possession of these circumstances or that state of being which is attended enjoyment Usage: Happiness is generic, and is applied to almost every kind of enjoyment except that of animal appetites.

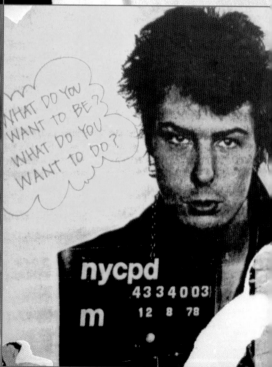

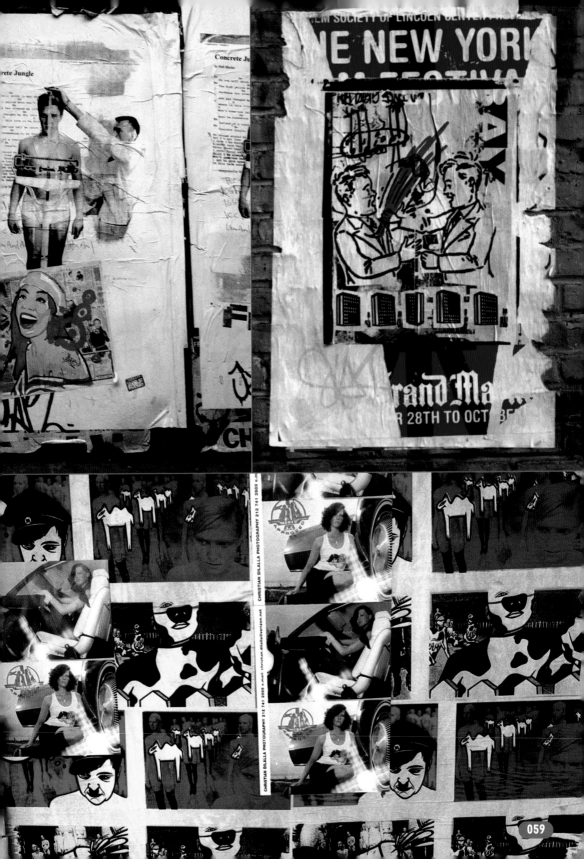

STENCILS The stencil provides a quick, efficient, and accurate way of applying a graphic to a surface. Though a considerable degree of detail can be executed, many rely on heavy "shadows," wherein the elements of the graphic are solid blocks of color (generally black spray paint). Andre the Giant, propagated by Shepard Fairey, is one widely recognized stencil. (Fairey's work has graced the streets internationally, and has also been featured on the walls of the New Museum of Contemporary Art.) Familiar faces fill in the ranks. Celebrity is democratized on the streets of the city. Recognizable faces appear printed in multiples on brick walls, construction material, and bases of telephone poles.

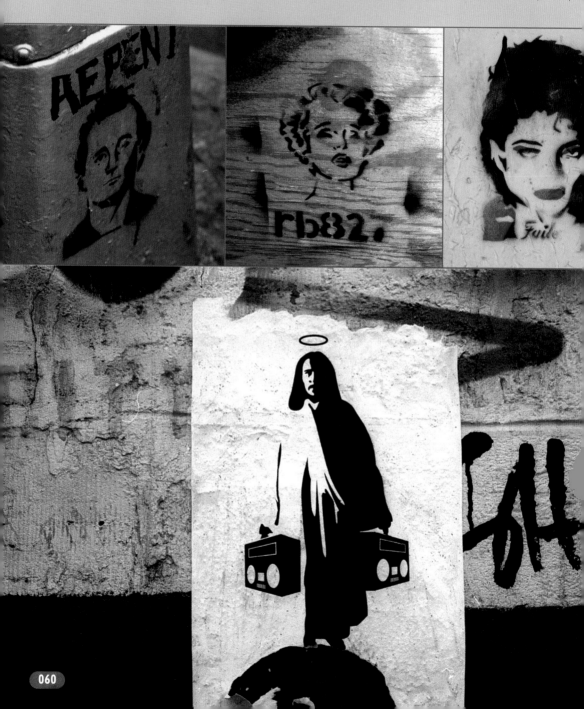

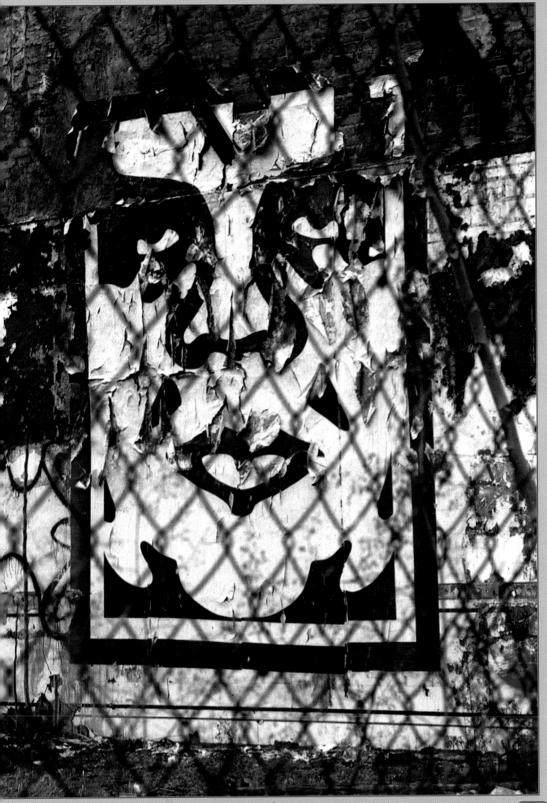

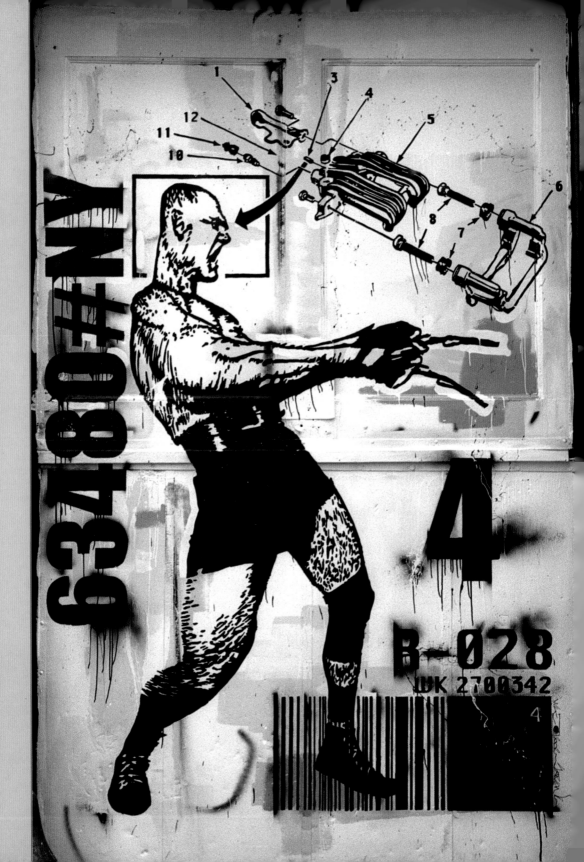

UCK
NO
EVIL?

PRAY
FOR
PILLS

PAY
NO
BILLS

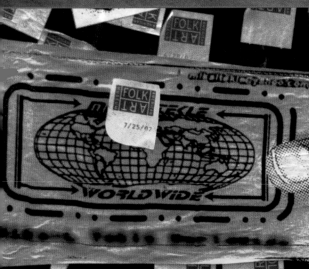

STICKERS AND FLYERS In addition to the individual branding campaigns waged with stickers, stencils, and w
pasted posters, the streets are awash with the graphic noise of flyers. Advertisements for club nights, band appearan
rooms for rent, mans with vans, and lost kittens appear along with other quotidian communications. From the mc
basic, handwritten scrawl to creative photocopying, these layers of text and image wallpaper the city in niches o
heavy pedestrian traffic.

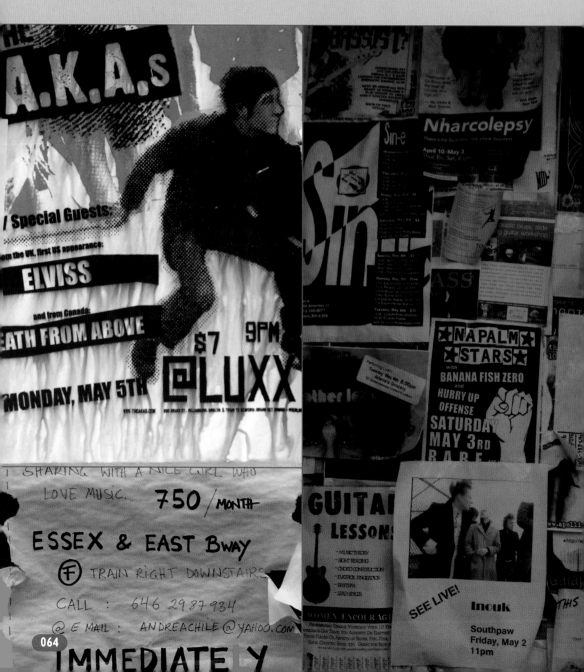

Luna Lounge

171 Ludlow St.
(Houston & Stanton)

F to 2nd Ave
JMZ to Dalancy

ELECTRIC TURN TO ME

TUE 06 MAY
9.30PM
FREE

with
All the Ghosts
and Viva Caramel

www.ElectricTurnToMe.com

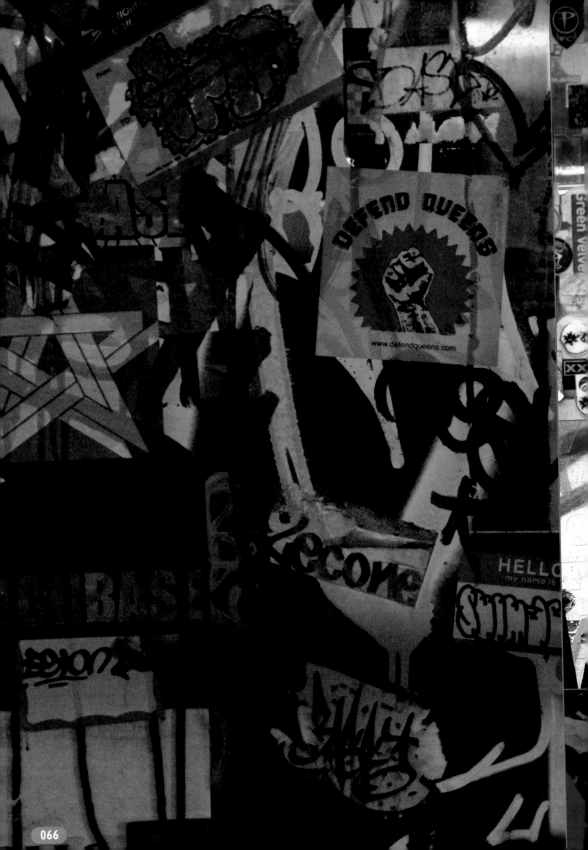

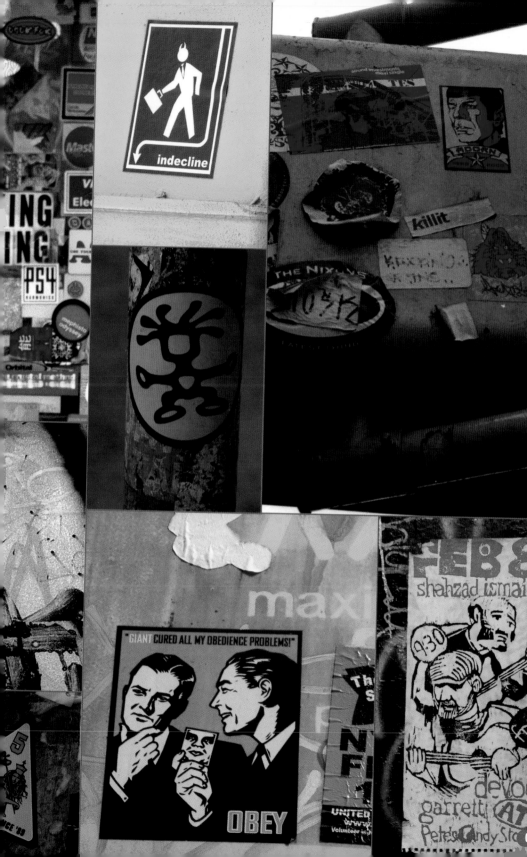

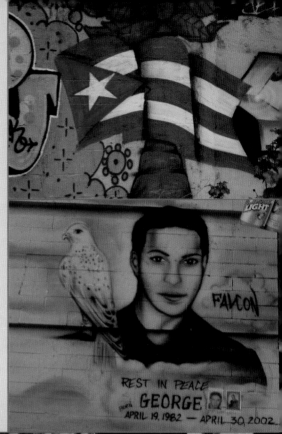

MURALS AND MEMORIALS Those areas of the city that retain a unique neighborhood flavor have embedded their native aerosol art form into the local landscape. The community-themed mural or memorial is a natural extension of graffiti writing. Local heroes, those who died in youth, historical figures, and cultural icons are paid homage, with likenesses incorporating inspirational messages or gentle admonishments.

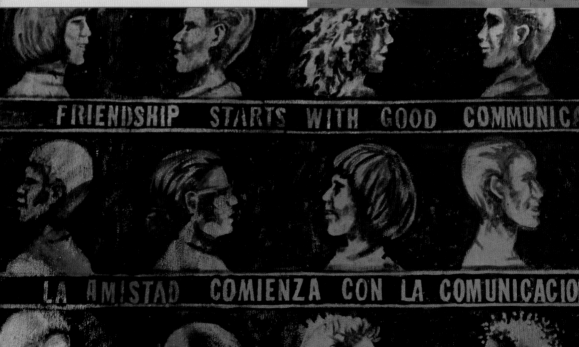

FRIENDSHIP STARTS WITH GOOD COMMUNIC

LA AMISTAD COMIENZA CON LA COMUNICACIO

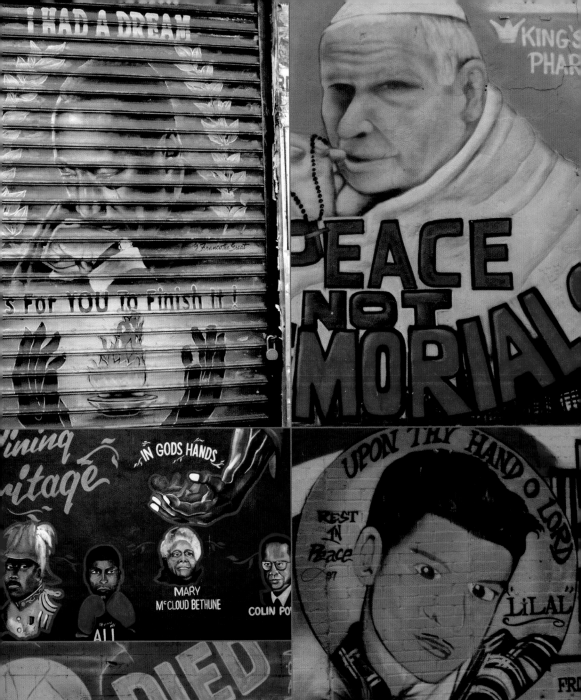
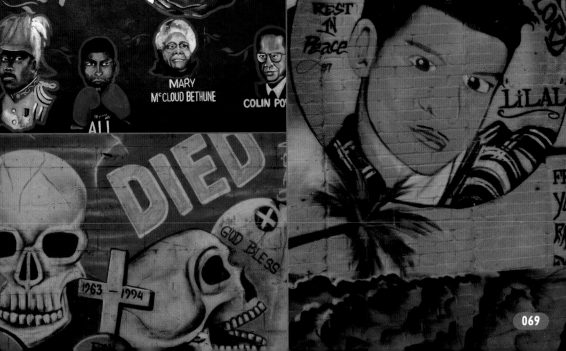

HOLD THE MAYO

Just what is American food? Hamburgers? French—pardon me—"Freedom" Fries? Hot dogs? Pizza? New York traf
in these, and then some. This city caters to just about every kind of food out there. The immigrant communitie
have sliced up sections of the city, creating enclaves of cuisine imported direct from back home. In some case
as with Chinatown and Little Italy, the different areas may very well be two sides of the same city block! Stree
vendors are another staple for famished and rushed New Yorkers. Depending on the season, you can get roaste
chestnuts, honey-roasted peanuts, or flavored ice slushies. But whatever the time of year, you can always get
yourself a hot dog heaped high with mustard and sauerkraut, or a salty pretzel. Not to infer that New York doe
not abound in more "high class" fare and have its own share of four- and five-star restaurants and celebrity
chefs, but somehow, one of the most representative New York City delicacies is the bagel, that lovely round vis
in dough. For a short period of the city's history, there was even a workers' union for bagel makers—the Bagel
Bakers Local #338 Union. Bagel bakers of the world, unite!

Cocktail culture is another aspect of urban living that has become practically synonymous with the good
life in Gotham City. From the boozy dive awash in neon to the high-class boîte serving pomegranate martinis
there's something very cosmopolitan (no pun intended) about alcohol when it's served right. New York City pri
itself on its nightlife, and as with food, there's something to be found for everyone.

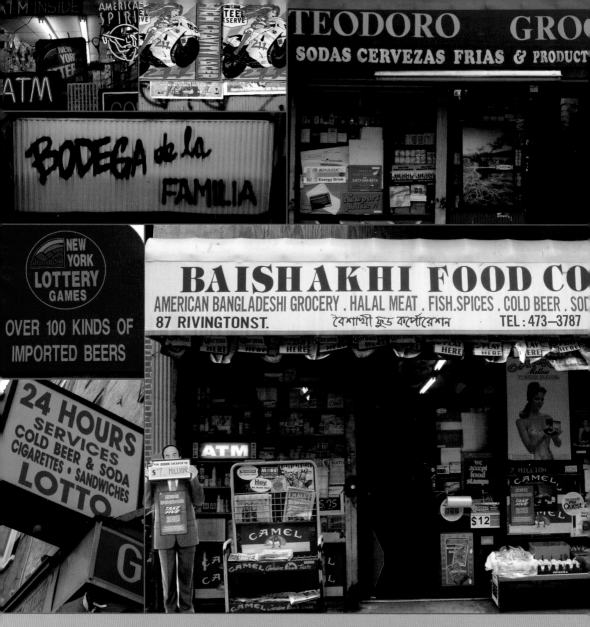

24-HOUR SERVICE The New York Deli—it's practically a brand name, conjuring up visions of bagels, malt liquor, lottery tickets, and hot coffee. The typical, family-owned deli is a holdout against the megamarts, reflecting the personal style and background of the owner, be they Korean, Bangladeshi, or Pakistani. And if you believe the legend on the side of the iconic coffee cup doled out across the city, all are equally HAPPY TO SERVE YOU. This paper coffee cup has a few variations, but is inevitably printed in police-uniform blue and golden-rod brown, with a Greek motif of some kind: an amphora or two, a discus thrower, women in togas. Introduced in 1967, these cups remain the caffeine delivery system of choice for delis and coffee carts throughout the city.

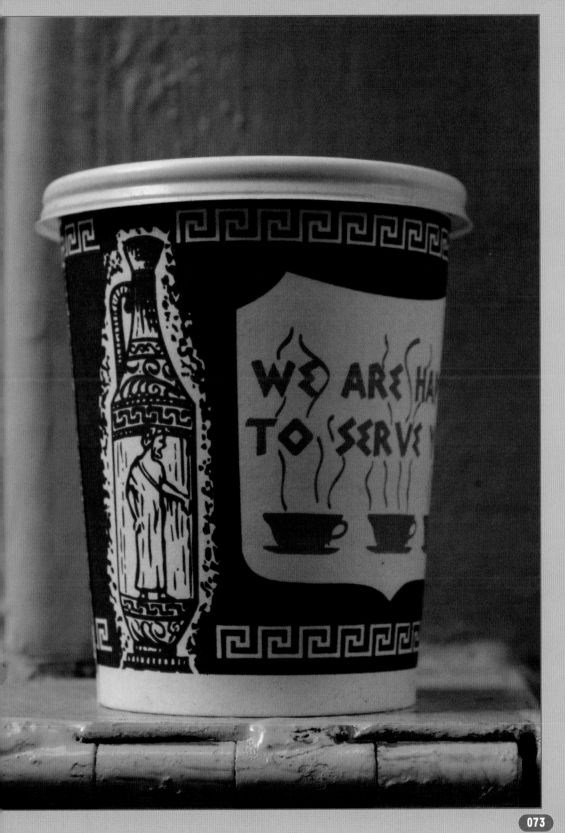

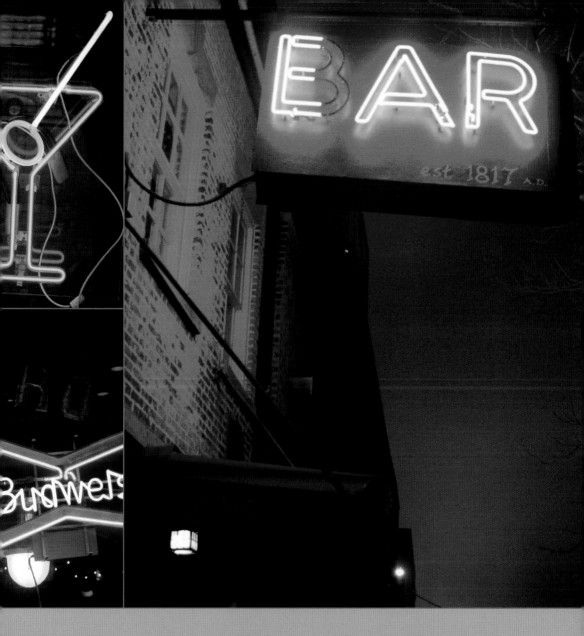

Y HOUR Trendy New York bars come and go, but you can tell a venerable institution by its signage. The faded n lettering on glass feigns elegance, but the flashing red, sputtering neon B A R actually means "dive." A montage rtini-glass shapes and flickering letters aglow in neon colors inspires thirst in the most upright of individuals.

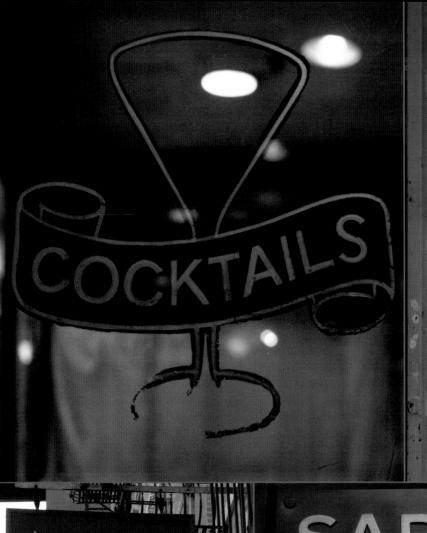

COCKTAILS

HAPPY HOUR
monday to 3-7 friday
COCKTAILS

HAPPY HOUR
monday to 3-7 friday
COCKTAILS

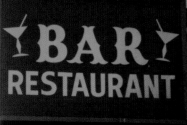

BAR RESTAURANT

SARDI'S RESTAURANT AND GRILL

"The Little Bar

DYMPHN

LICENSED TO SELL
BEER , WINE & SPIRITS
SEVEN DAYS A WEEK

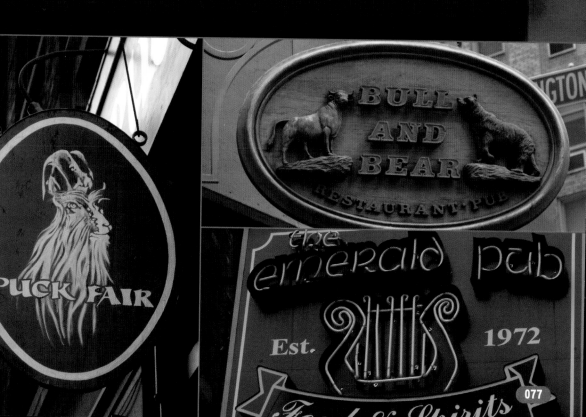

PUCK FAIR

BULL
AND
BEAR

RESTAURANT·PUB

NGTON

the emerald pub

Est. 1972

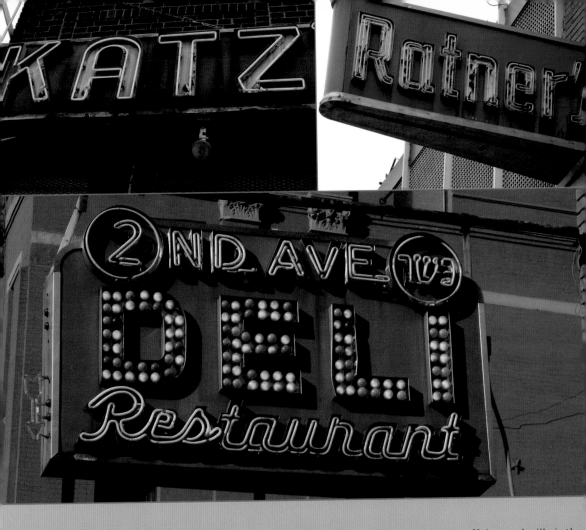

DELIS AND DINERS Separate from the "corner" deli, fine purveyor of daily nicotine, caffeine, and milk, is the traditional New York deli-restaurant—predominantly Jewish cuisine, tables overflowing with kosher pickles, and savory mountains of pastrami and corned beef. Three classic examples are: Katz's and Ratner's in the Lower East Side, and the 2nd Avenue Deli just a few city blocks up in the East Village. Seen today, the block sans-serif letteri is both modern and historic, with a classic 50s-diner palette of pastel blues, faded neon reds and pinks, burgundy and brick. The continuing influx of populations to New York brings a new dining demographic with each wave. Italia Chinese, Indian, and Mexican are the most obvious menus one encounters, but for "middle-rung" dining of any stri (not exactly a dive, but not four-star by any means) the signage relies on the same motifs: pictures of welcoming mom's, enticing representations of featured dishes, and that familiar neon lettering.

CELLENT
DUMPLING HOUSE

ROSE OF BOMBAY
FORMERLY
KISMOTH

RESTAURANT | CHOPS STEAK
BREAKFAST • LUNCH • DINNER

illo De Jagua Rest.

EL CASTILLO
DE JAGUA
RESTAURANT
TEL. 982-3412.

11

Southern Fried Chicken

MARION'S
CONTINENTAL

estaurant & Lounge

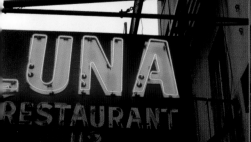

UNA
RESTAURANT
112.

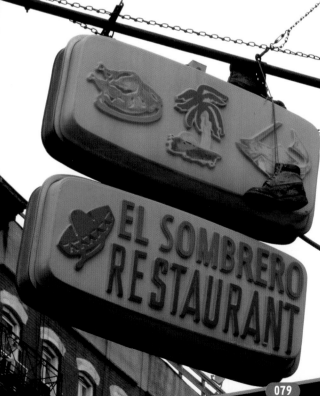

EL SOMBRERO
RESTAURANT

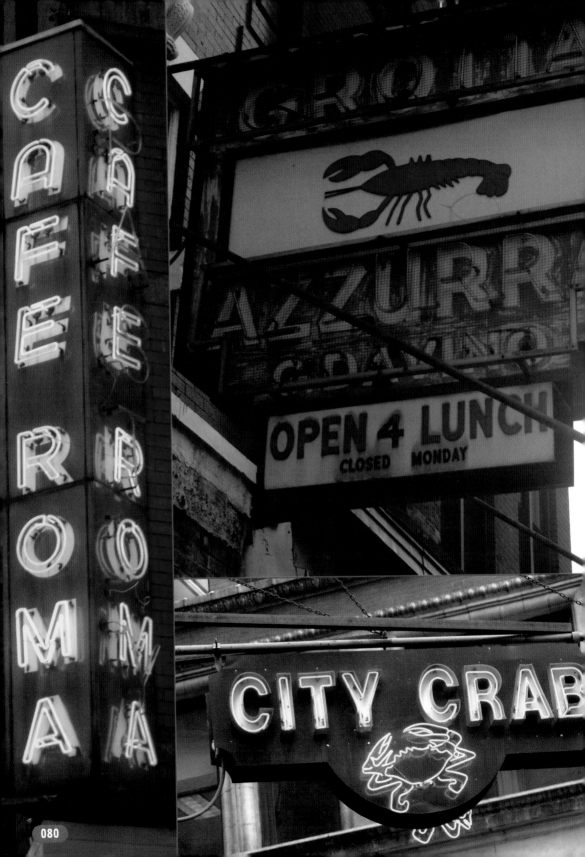

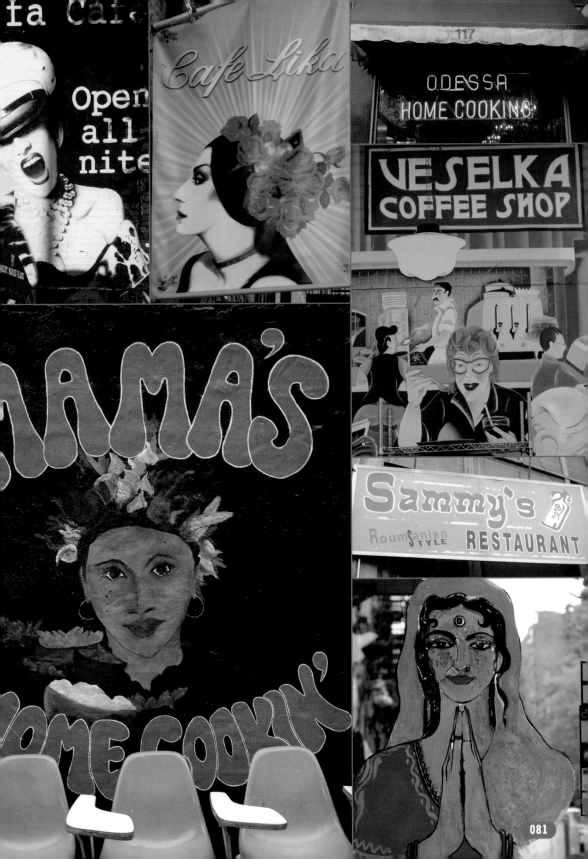

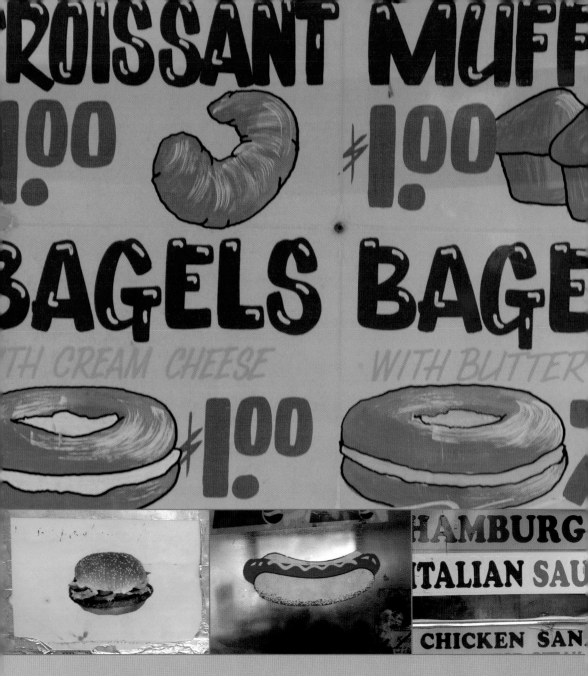

STREET VENDORS For the honor of finest New York contributions to the palette, it is a toss-up between the fa
hot-dog cart and the omnipresent pizza parlor. Hometown favorites, the standard goodies are advertised with h
lettered or preprinted signage in ketchup red and mustard yellow. And then there is the smiling Mister Softee and
imitators—custard cones and ice-cream sandwiches sold from brightly decorated vans. The tinny sound of an ice-
cream truck's "theme music" means that spring has finally arrived in New York.

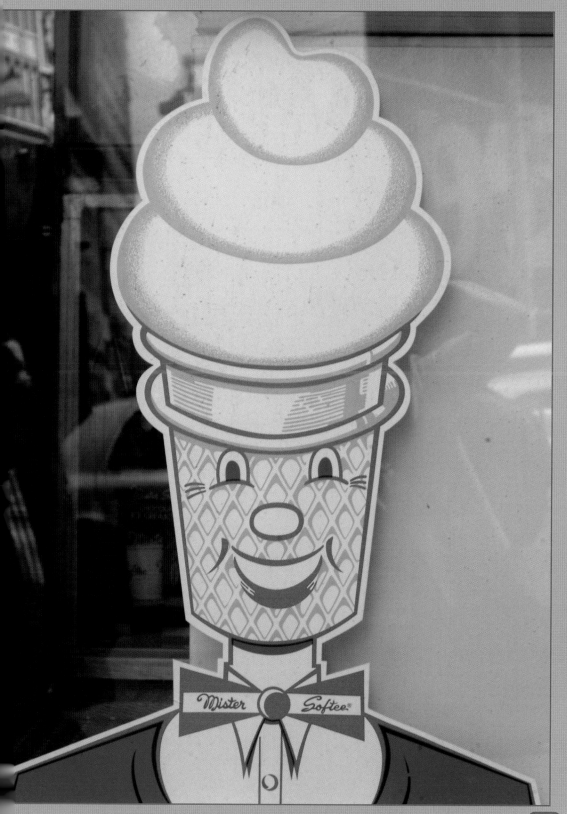

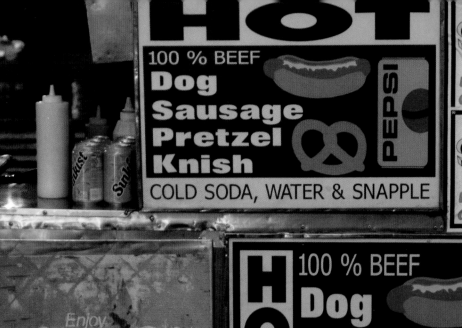

HOT

100 % BEEF
**Dog
Sausage
Pretzel
Knish**

PEPSI

COLD SODA, WATER & SNAPPLE

SABRETT

WE'RE
ON A ROLL !!!

SABRETT

WE'RE
ON A ROLL !!!

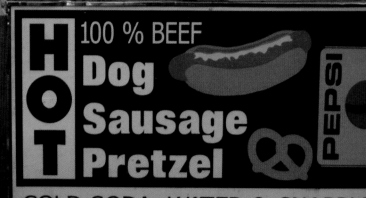

100 % BEEF
**H
O
T**
**Dog
Sausage
Pretzel**

PEPSI

COLD SODA, WATER & SNAPPL

Enjoy
Coca-Cola

Trademarks ®

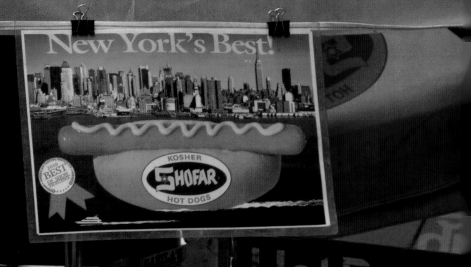

BEEF HOT DOGS

New York's Best!

2006
BEST
OF SHOW

KOSHER
SHOFAR
HOT DOGS

Hot Dog

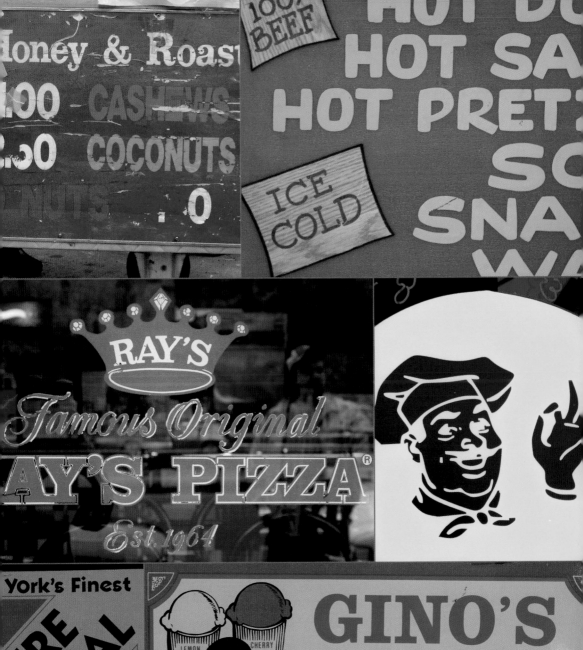

Honey & Roast

1.00 — CASHEWS

2.50 COCONUTS

NUTS 0

100% BEEF

HOT DO

HOT SA

HOT PRET:

SO

ICE COLD

SNA

WA

RAY'S

Famous Original

AY'S PIZZA®

Est. 1964

York's Finest

PIRE

ATIONAL

Kosher
All Beef
Franks and
Hot Smoked
Beef Sausage

Produced Under Strict Orthodox
Rabbinical Supervision
nt Inspected

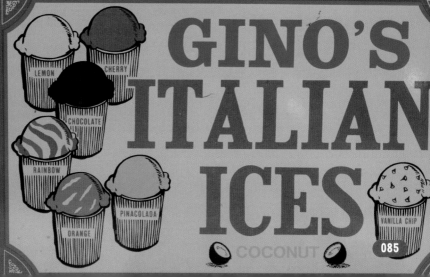

LEMON CHERRY

CHOCOLATE

RAINBOW

PINACOLADA

ORANGE

GINO'S

ITALIAN

ICES

VANILLA CHIP

COCONUT

LETTERS, NUMBERS, SIGNS

I Shop, Therefore I Am. Artist Barbara Kruger once had a billboard with this slogan on the side of a Tribeca wareh
Would New York exist without shopping? Certainly the landscape of graphics would be a great deal plainer. Fro
carefully printed (or dreadfully scrawled) price tags to the looming giants that walk among us in their underwe
the visual noise around you is full of information and enticements created solely for the shopper. Are you par
a subculture? You must first collect the appropriate accoutrements, available at an appropriately themed sh
Even the Museums have embraced their own product lines. Crass commercialism or tourist attraction? You be t
judge. Giganimous billboards have sprouted up all over the city. Few building facades are left unaccompanie
a much larger-than-life model. And with marketing the way it is, confusion is easy. Is that a billboard advertisen
or a snap shot of a local heroin addict caught in his underwear? Maybe it's an ad for jeans, cologne, wireless
service, or radial tires? Who knows. The point is that there is little surface area left in the city that hasn't bee
leased. Plus, with revised ordinances allowing for billboards to be a maximum of six stories, architecture seem
just get in the way. Building or billboard. Difficult to say sometimes. Perhaps architects will dispense with all g
and fixtures in the near future and simply give building owners an abundance of lease-worthy flat surface.

While the billboards overhead may be filling up the visual plane, the true barrage of information is appare
street level. For a city in which everywhere is a somewhere, a navigational system would become a mishmash
information if not for design. The varied street, traffic, and shop signs are all somehow harmoniously interrela
in function and form, making up the quotidian traffic of information and commerce.

AVENUE A

EAST THIRD STR

5 AV ONE

W 72 ST

CENTRAL PARK WEST

UPPER WEST SIDE HISTORIC DISTRICT

CENTRAL PARK
WEST

EXPANDED CARNEGIE HILL HISTORIC DISTRICT

5 AV/MUSEUM MIL

464 T.&A. COFFEE CO. INC. 46

135 HUDSON STREET

7 AV

E THE PRES

ACTORS SQUARE

DUFFY SQ

19

ONE

1540 BROADWAY

1155

PLEASE
PRESS BUTTON
TO ENTER
→

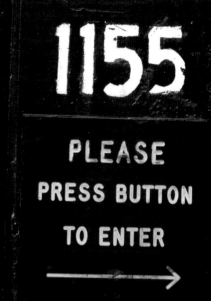

PRESS BUTTON TO ENTER

New Yorkers are proud of the logical grid that governs the city's address system. Avenues go north and south, streets go east and west. "Fifth" neatly splits most of the city up into east and west. So if you're at the corner of 7th and 7th, there should be no confusion; unless of course, you happen to be in the Village, where the streets chaotically run into one another—or below Houston, where streets and alleys date back to a time before the Civil War.

DECO STYLE New York City came into its own during the art deco period and, in no small part, the style of that era both shaped and was shaped by the growth of the metropolis and by the speed and trajectory of peoples and things through its streets. Built in the '30s, the Rockefeller Center, and in particular the Rainbow Room, on the 65th floor of Thirty Rockefeller Plaza, represented the extreme in elegance and was a symbol of New York's capacity for urban development. Sans-serif fonts, streamlined and clipped of any extra line that weighed them down, abound in the typography of that time. Other styles, each symbolic of an ethos of the era—strength, security, ethnicity, history, culture—left their marks in a function-appropriate manner.

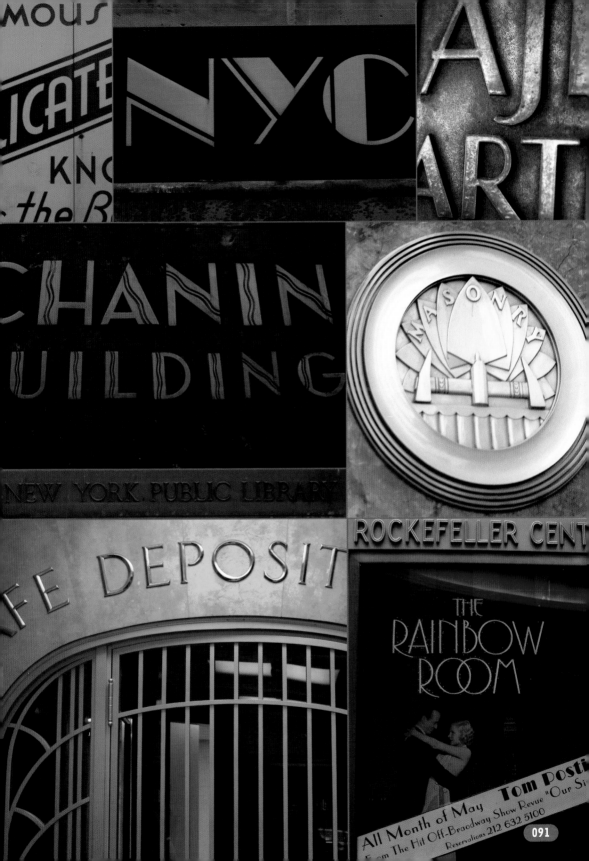

THE PRICE IS RIGHT With street vendors, who offer a fixed fare at a set schedule of prices, poster lettering is a common sight. Grocery stores, on the other hand, tend to rely on hand lettering to accommodate their changing price and availability of produce. The same is true for the daily menu of restaurants (commonly written in chalk on blackboard). This human element is a nice, homely touch when the pressure of the city has got you down.

Preceding spread: Gilt letters offset with a black outline are found on the glass of windows and doors throughou the city. Sometimes in cursive, announcing an elegant or professional name, other times in block letters that procla an officiousness or staunchness, and still others barely visible for age and wear, signifying "I've been here a long time The Ear Inn has been on the same site in one form or another long enough to proudly display its year of establishme below its name.

SPEAKERS

WALKMAN

...MERICAN RECORDS

MACHINES ★

...AKERS ITALIAN FLAGS

...TI BOWLS ★

...GLISH COOK BOOKS

GEORGE'S
COFFEE OR TEA 60¢
SANKA HOT CHOCOLATE 60
DONUTS 50
DANISH
CROISSANT
BAGELS WITH CREAM CHEESE $1.00
BUTTERED ROLLS
ASSORTED MUFFINS
COLD JUICE 75¢

...RKING

...EYERS

...ARAGE

...ET 1ST AND 2...

...NNER ONLY

...UNCH

...BSTER

...BSTER

EAR INN
Est. 1817

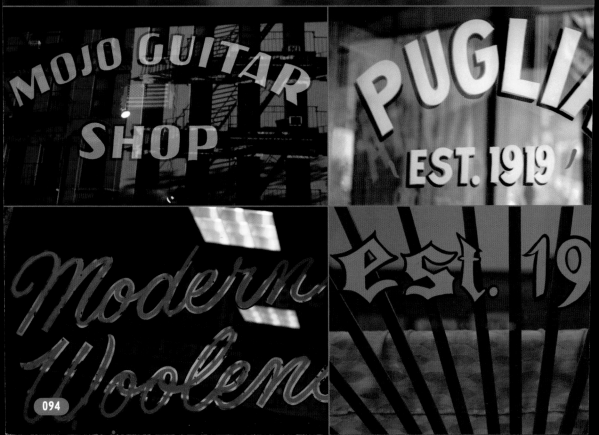

MOJO GUITAR SHOP

PUGLI..
EST. 1919

Modern
Woolen

est. 19

ST. BA
PANY

270

WALKER & BAILEY
LAW OFFICES

1NG

SOCIATION OF THE
OF THE
Y OF NEW YO

Marion.
CONTINENTAL

BRICK SIGNS Before megabillboards started their takeover of the city, brick signs were one of the most prominent forms of advertising around town. Painted by hand directly onto the brick surface, these graphics have an added, complementary layer of texture. Windows and trellises can add or detract, depending on the sense of humor of the sign creator. Straddling the line between real graffiti, mural paintings, and billboards, these oversized advertisements have become effectively integrated with the feel of the street.

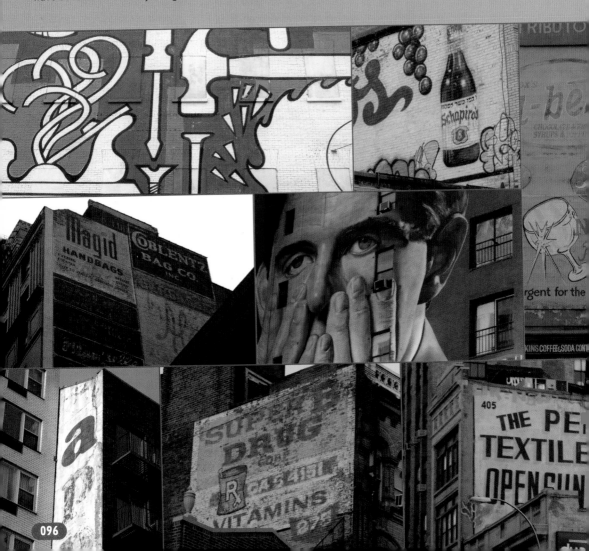

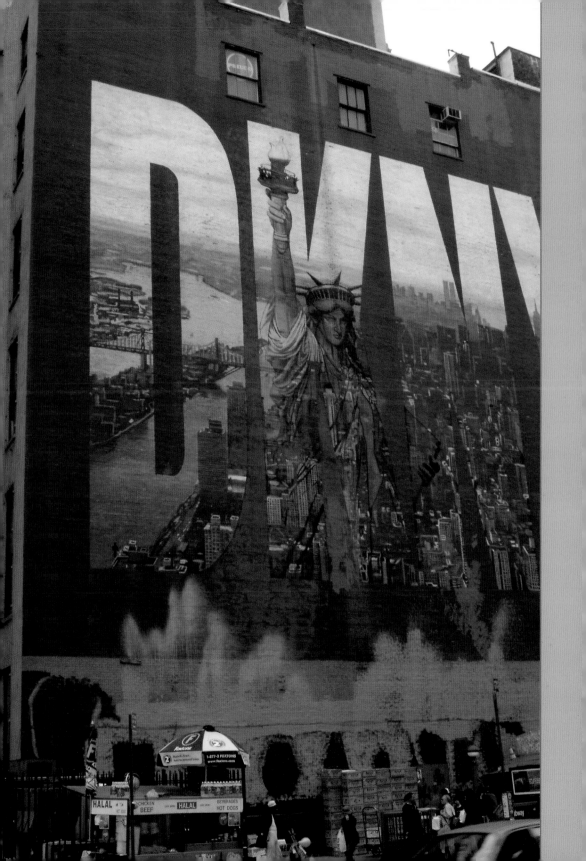

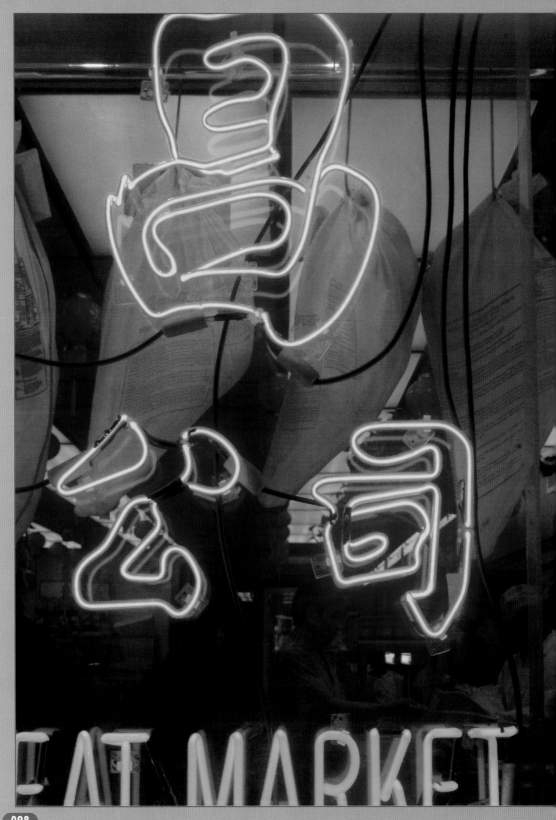

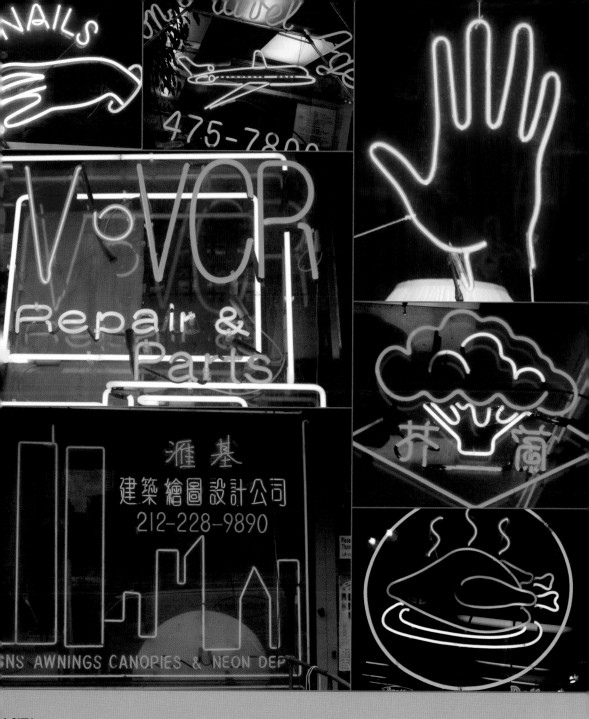

N CITY Neon isn't the only ingredient used for these signs. A combination of argon, mercury, helium, and colored g generate the spectrum. The round, glass tubing is generally about $^3/_8$in (1cm) in diameter and cannot be ned to generate wide surfaces of neon. Instead, these signs rely on mapping the basic contour of a shape. orm has allowed for the continued expansion of neon not just as advertising but also as art.

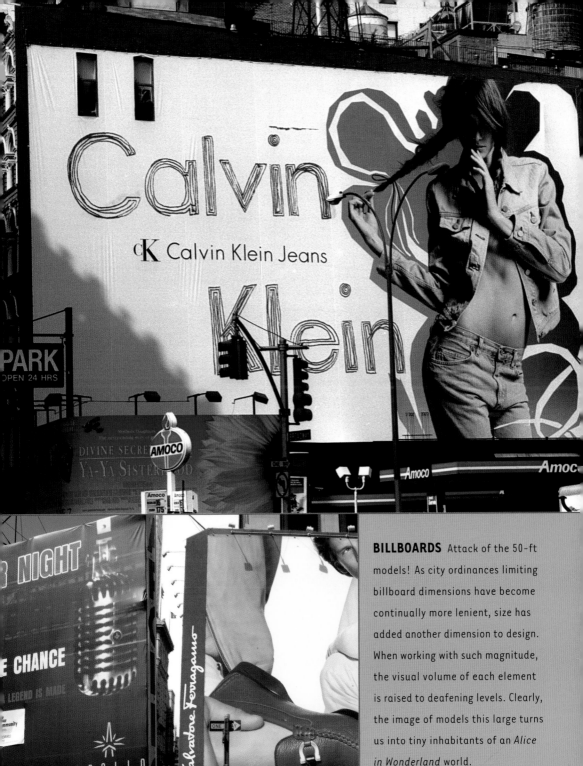

BILLBOARDS Attack of the 50-ft models! As city ordinances limiting billboard dimensions have become continually more lenient, size has added another dimension to design. When working with such magnitude, the visual volume of each element is raised to deafening levels. Clearly, the image of models this large turns us into tiny inhabitants of an *Alice in Wonderland* world.

BEN FREEDMAN
GENT'S FURNISHINGS
Since 1927 A Tradition
on Orchard St.

Cartier's Building

FABRICS!

Fine & Klein
119 HANDBAG

Fine & Klein
HANDBAGS

LEA'S
Designer Fashions

ITAL L
WARE
FOR TH
119 ORC

BY APPOINTMI

VARIETY

169 ★ D and J ★ 169
VARIETY STORE
CANDY SODAS HEALTH Supplies & BEAUTY Supplies

HENRI BENDEL

HENRI BENDEL
NEW YORK

SHOP SIGNS There are simple ways, and there are complex ways to let a casual passerby know what they might find in your store, thereby enticing them in. The simplest way is to list the items one might find inside—fabrics, pharmaceuticals, or fine men's suits. The more complex way is to create a brand and for that brand to project the emotion one might feel upon purchasing said brand. It doesn't matter what's inside at that point. You still want it.

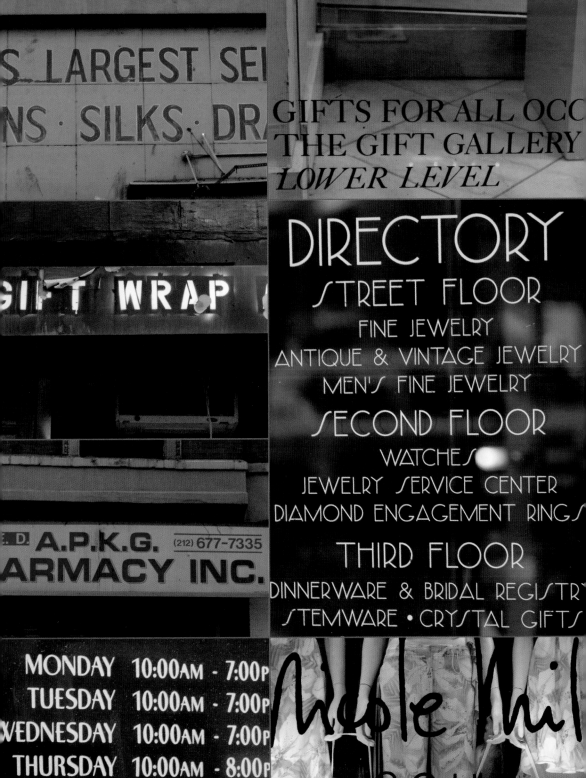

'S LARGEST SE...
NS · SILKS · DRA...

GIFTS FOR ALL OCC...
THE GIFT GALLERY
LOWER LEVEL

GIFT WRAP

A.P.K.G. (212) 677-7335
ARMACY INC.

DIRECTORY
STREET FLOOR
FINE JEWELRY
ANTIQUE & VINTAGE JEWELRY
MEN'S FINE JEWELRY
SECOND FLOOR
WATCHES
JEWELRY SERVICE CENTER
DIAMOND ENGAGEMENT RINGS
THIRD FLOOR
DINNERWARE & BRIDAL REGISTR...
STEMWARE · CRYSTAL GIFTS

MONDAY 10:00AM - 7:00P
TUESDAY 10:00AM - 7:00P
WEDNESDAY 10:00AM - 7:00P
THURSDAY 10:00AM - 8:00P
FRIDAY 10:00AM - 7:00P
SATURDAY 10:00AM - 7:00P

SOH...

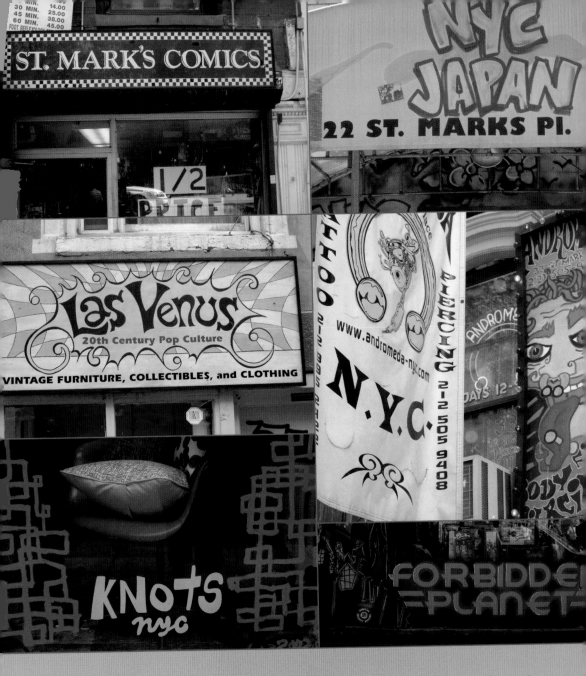

SHOPPING REBELS Some have observed that New York City derives part of its energy from being both a center of commerce, and a center of culture. Wealth can support culture; it can underwrite museums or donate to a musician's fund. Or, wealth can buy culture; pieces of art, CDs, fashion... Ultimately, wealth might think it can buy a social identity. You just have to know where to shop.

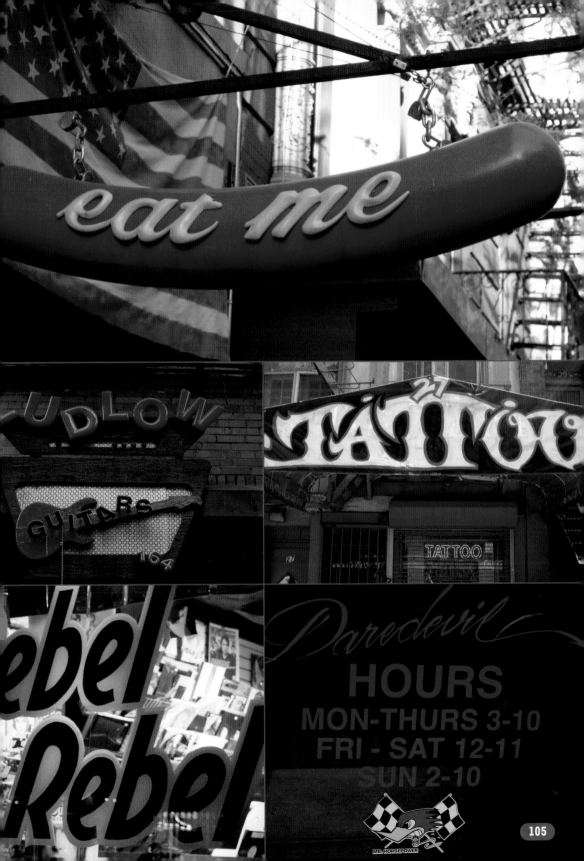

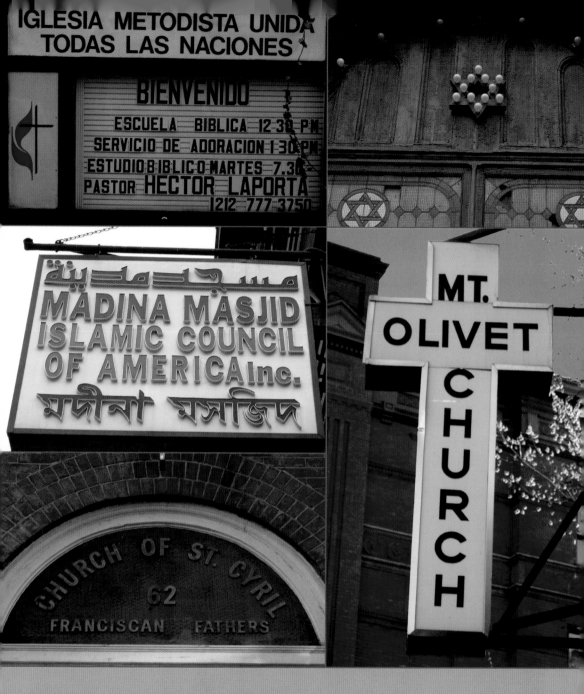

IGLESIA METODISTA UNIDA
TODAS LAS NACIONES

BIENVENIDO

ESCUELA BIBLICA 12 30 PM
SERVICIO DE ADORACION 1 30 PM
ESTUDIO BIBLICO MARTES 7.30
PASTOR HECTOR LAPORTA
1212 777 3750

مسجد مدينة
MADINA MASJID
ISLAMIC COUNCIL
OF AMERICA Inc.
মদীনা মসজিদ

MT.
OLIVET
CHURCH

CHURCH OF ST. CYRIL
62
FRANCISCAN FATHERS

OTHER PATHS New York City is not alone in priding itself on being a tolerant city, but somehow the gentle reminde
crosses and Stars of Davids side-by-side reassures that it might actually be possible to coexist. All are advertisemer
make no mistake, but they are also the handiwork or call sign of the local community.

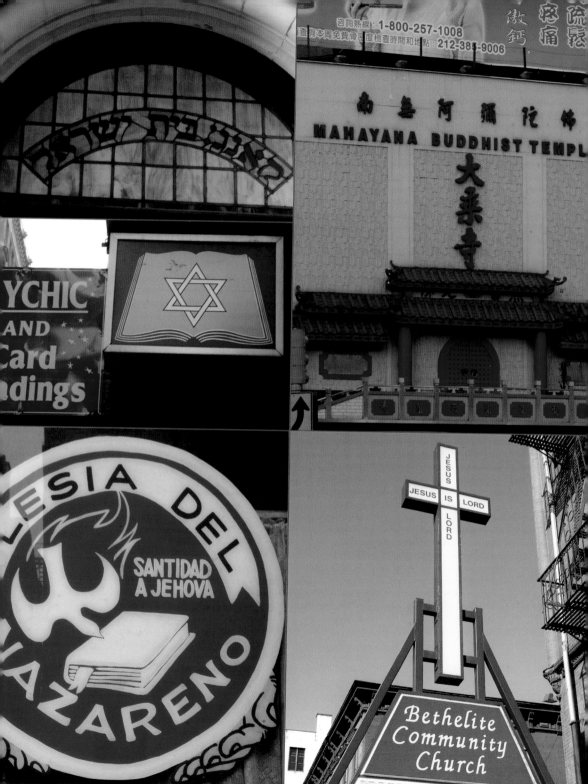

BIG CITY, BIG LIGHTS

From first-class productions like *Shakespeare in the Park* to economy-class productions like *Shakespeare in the Parking Lot*, the city has a broad spectrum of events to satisfy the needs of all on a daily basis! Sunday's a matinee, Monday a film festival, then Tuesday it's ice hockey, Wednesday a jazz club, Thursday a guided walk, and Friday a concert at the Garden. The choices are limitless. A performance or an event has to work hard to get your attention. Take the ample variety of theater. You can see one of the endless long-running Broadway musicals like *The Phantom of the Opera* and *42nd Street* (will we ever get over the loss of *Cats* and *Les Miz* *sniff*?), or new classics like *Aida* and *The Lion King*, or *Hairspray* and *The Producers*. Or, you can go off-, off-off-, and even off-off-off Broadway (aka Williamsburg or Jersey) for performances of lesser-known genres. The tale of an Off Broadway show that claws it all the way to Times Square (like *Rent* or *Urinetown*) is the epitome of the reason boys and girls from Iowa run away to "Make it Here"—from nobody to Megastar, this is the place to do it.

The larger-than-life, lit-up signs are a unique part of the visual extravaganza of New York City's streets. Even the MTA and the police department have upped the voltage of their signage to "blend in" with their environs. The history of Times Square (named after the newspaper *The New York Times*) as a media-dominated landscape and that of the flashy Broadway theatre marquee are intertwined.

In 1904, *The New York Times* moved their offices to One Times Square and threw an inaugural party on New Year's Eve. This coincided with the start of the electric sign era. At the theaters, electric signs began to jut out from the sides of brick buildings, each uniquely shaped, a clamor of flashing dots lighting up the dark streets the city. The night was now longer and more exuberant. Since then, the intersection of Broadway and 42nd has become a nexus for economic growth, innovative architecture and signage, and social entertainment of the highest and lowest order. With commerce and theater comes sex, and another key element of this area and the visuals that go with it, is the seedy aesthetic of "adult entertainment."

But in recent years, in a campaign to clean up the area, a lot of the "peep shows" that helped define the nature of Times Square have been pushed out in favor of family-oriented retailers. Slowly, the gritty world that was captured in such films as *Taxi Driver* and *Midnight Cowboy* is being lost to Disney, MTV, and the World Wrestling Federation.

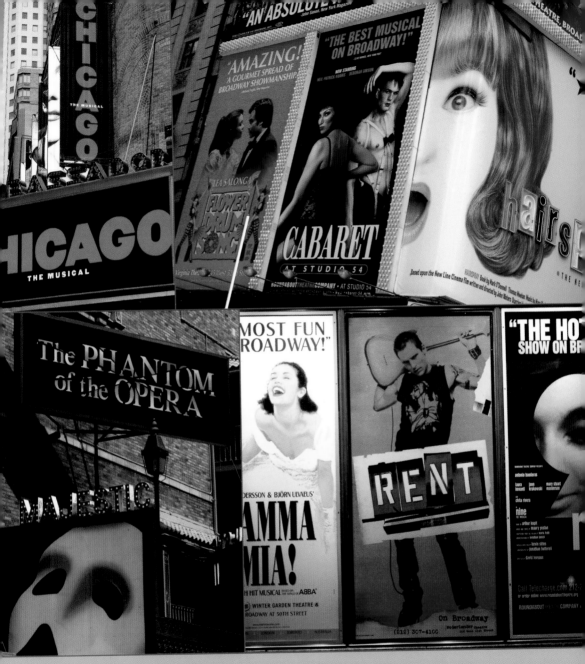

THE HOTTEST SHOW "A Great Big Fat Gorgeous Hit!" "Amazing!" New York is the city of superlatives: the biggest, the best, the most awake, the most alive. It is a city to trumpet its successes. You want to see your name up in lights? This is the place to do it. From Radio City Music Hall to Broadway and the Bowery, the graphics of entertainment take on a myriad of shapes. Standing out from the clamor are the bare-bulb marquees harking back to the early days of Broadway. The huge, all caps, sans-serif lettering mounted on bare scaffolding are classic New York noir.

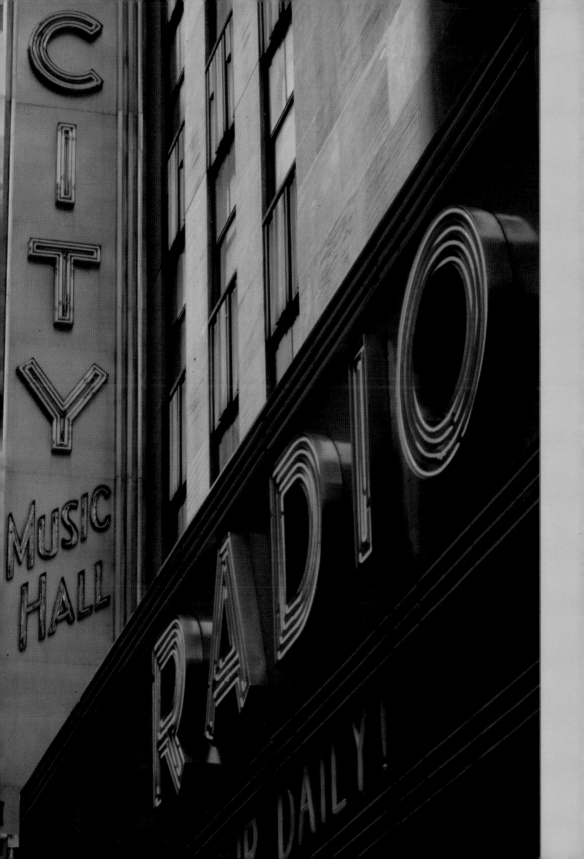

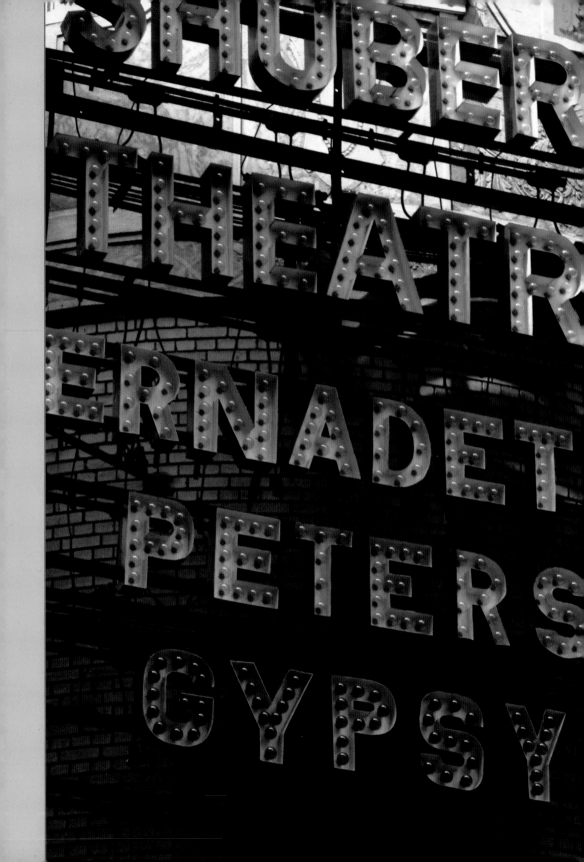

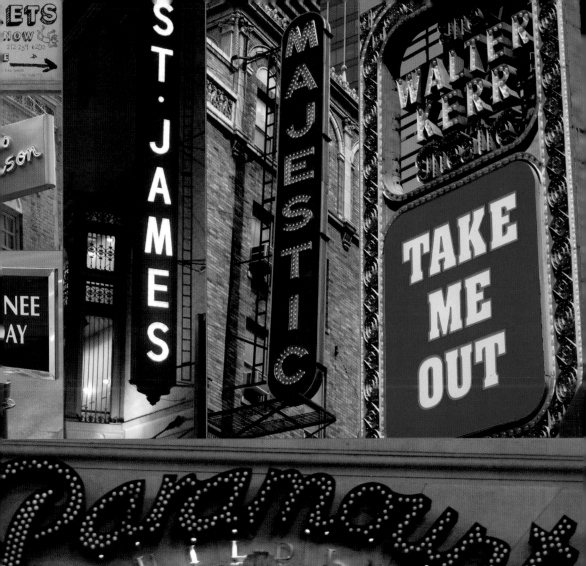

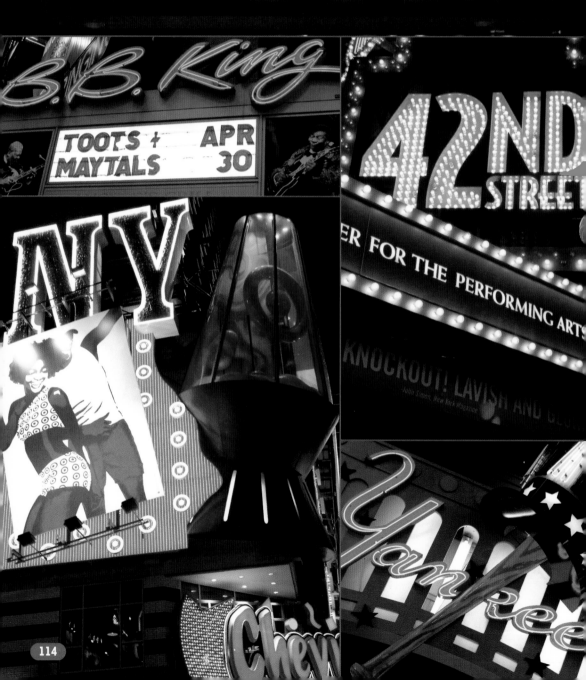

GHT LIGHTS As early as the '40s, Times Square set the standard for oversized, outrageous advertising ploys—
t billboards and steaming coffee cups paved the way for today's monsters from the minds of Madison Avenue.
t, three-dimensional juke boxes, lava lamps, and baseball bats compete for the attention of the overstimulated
strian. The key words are: bigger, brighter, and bolder. The contest for dollars is a constant cycle of consumer
e made manifest in fiber optics and electro-luminescence.

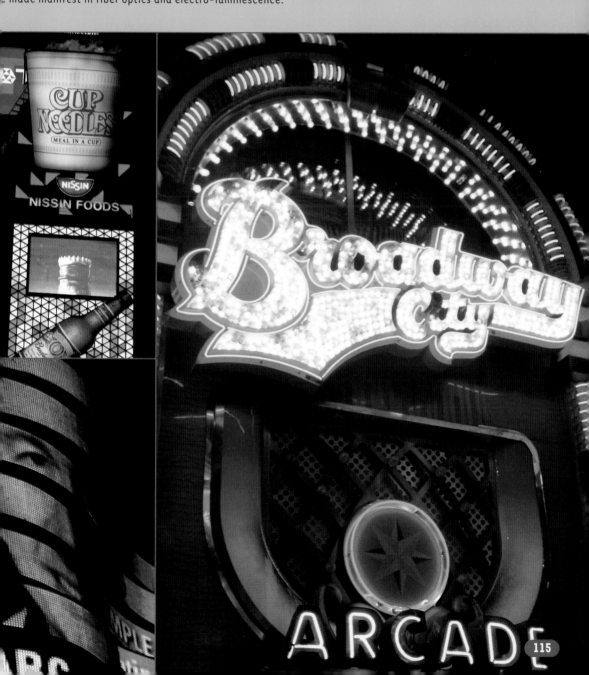

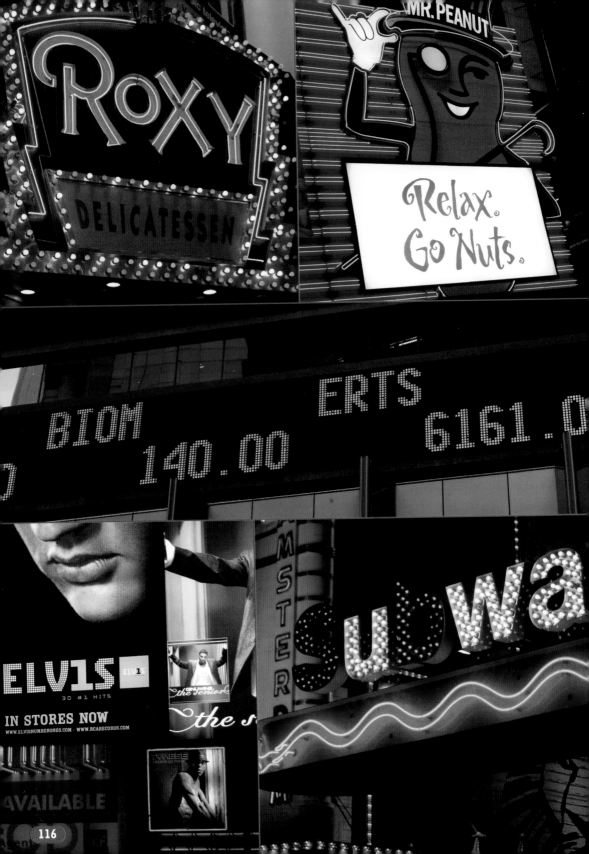

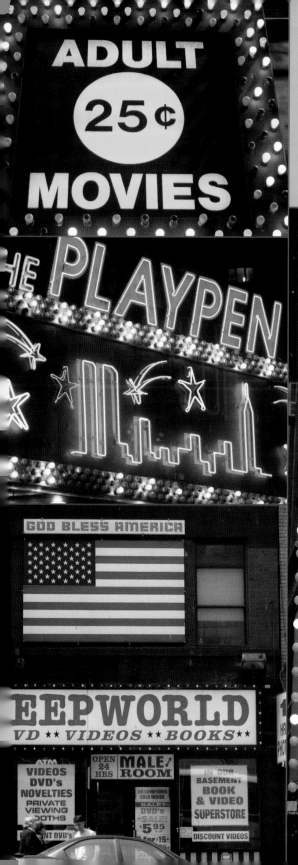

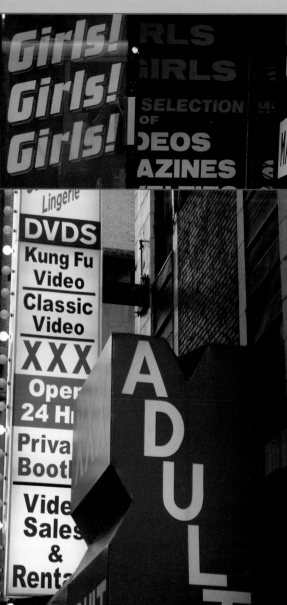

PEEP SHOW Despite best efforts to clean it up, Times Square persists as the adult entertainment center for New York City. The '70s remain the era of choice for the aesthetics of soft-core porn. Pulsing neon and dirty DayGlo promise erotic novelties; short-hand for porn and dildos, among other "adult" toys.

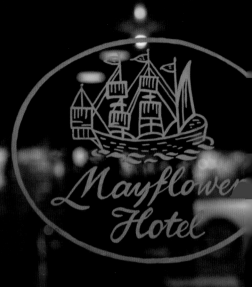

Mayflower Hotel

THE OLCOTT

The Plaza

HOTELS Classic, stately, regal. There's something about brass and gold-painted hotel lettering that makes you want to pull up to the curb in a tinted-window limousine. The signage for these classic hotels was created for an era when travel still had connotations of civilization and sophistication, and hotel lobbies were graced with literary and cultural figures, not terry-clothed tourists from the Midwest.

he St. Regis

ESSEX HOUSE
A WESTIN HOTEL

HOTEL

Algonquin

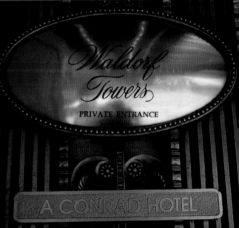

Waldorf
Towers

PRIVATE ENTRANCE

A CONRAD HOTEL

THE **IROQUOIS** NEW YORK

"HERITAGE OF NEW YORK"

ON THIS SITE
STOOD THE HOME FROM 1899 TO 1902 OF

WILLIAM DEAN HOWELLS

(1837 – 1920)

AUTHOR, CRITIC AND
CHAMPION OF REALISM IN FICTION

PLAQUE ERECTED 1967 BY
THE NEW YORK COMMUNITY TRUST

ANDMARKS OF NEW YORK

. REGIS HOTE

OMPLETED IN 1904, THI
HOTEL BUILDING IN
D BY TROWBRIDGE & L
STRUCTED BY MARC E
ONCEIVED AND OWNE
JACOB ASTOR, WHOSE
NLARGED THE ORIGIN
IN 1925.

HEATF

mber 1992 this plac
n of the leadership
Group (ATIG), MHT
the City of New Yo

hborhood Reflections"

the Studio in a School Program at P.S. 15
Third-grade classes, 1999-2000

tist/Instructor - Susan Greenstein
Studio Assistant - Marissa Perez

Principal - Barbara Bankowski
Assistant Principal - Pamela Watts

HERE DIED, ON JANUARY 7, 1943,
AT THE AGE OF 87, THE GREAT
W-AMERICAN SCIENTIST-INVENTOR,
LA TESLA WHOSE DISCOVERIES
FIELD OF ALTERNATING ELECTRIC
ADVANCED THE UNITED STATES
REST OF THE WORLD INTO THE
INDUSTRIAL ERA

YUGOSLAV-AMERICAN BICENTENNIAL
COMMITTEE, JANUARY 7, 1976

PLAQUES This is the mark of history: a rectangular brass plaque, turned greenish in hue, and covered with raised lettering. New York is dotted with these markers proclaiming birthplaces of noteworthy persons, architectural and cultural landmarks. Who cared enough to petition the city to place a plaque on the side of that building?

KEY MANTLE
RK YANKEES 1951 – 1969

GNIFICENT YANKEE
536 HOME RUNS

POPULAR PLAYER OF HIS ER

RECOGNITION OF HIS TRUE
ESS IN THE YANKEE TRADITION
OR HIS UNEQUALED COURAGE.

UE PRESENTED TO MICKEY MANTLE

THE METROPOLITAN
MUSEUM OF ART

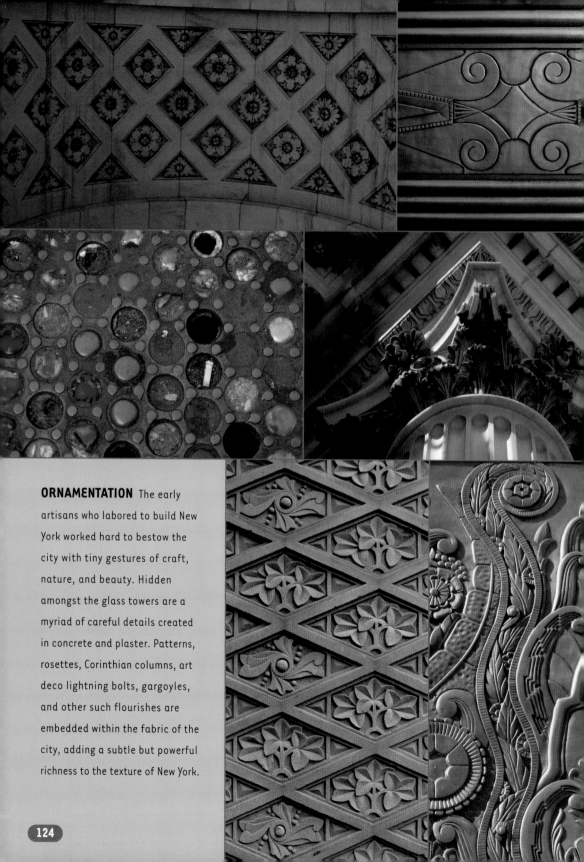

ORNAMENTATION The early artisans who labored to build New York worked hard to bestow the city with tiny gestures of craft, nature, and beauty. Hidden amongst the glass towers are a myriad of careful details created in concrete and plaster. Patterns, rosettes, Corinthian columns, art deco lightning bolts, gargoyles, and other such flourishes are embedded within the fabric of the city, adding a subtle but powerful richness to the texture of New York.

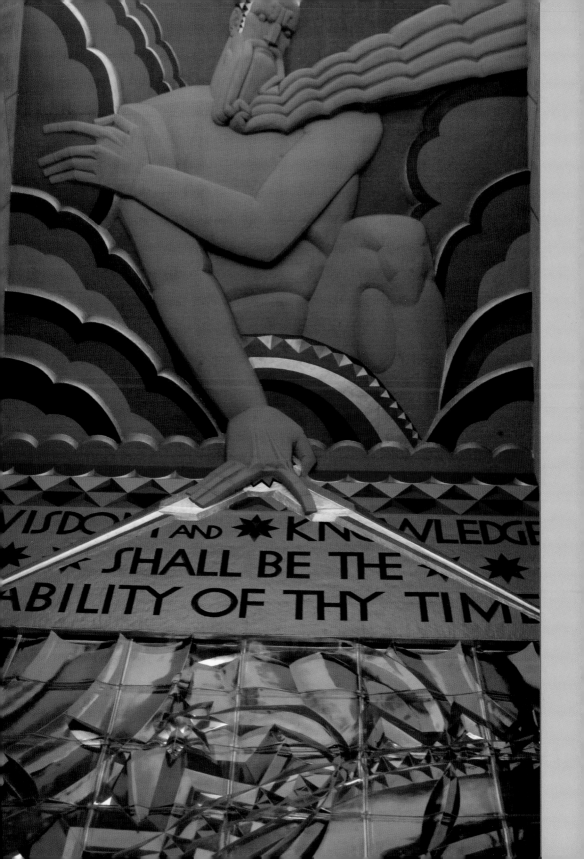

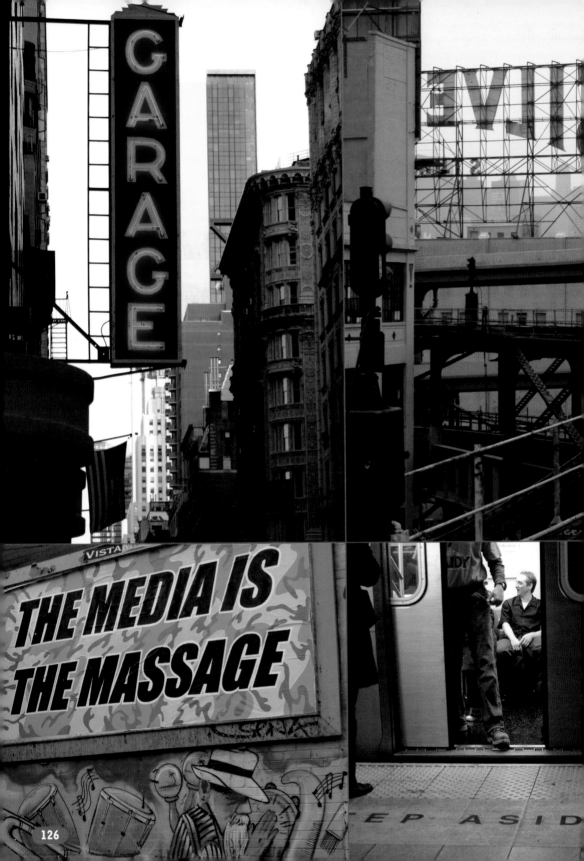

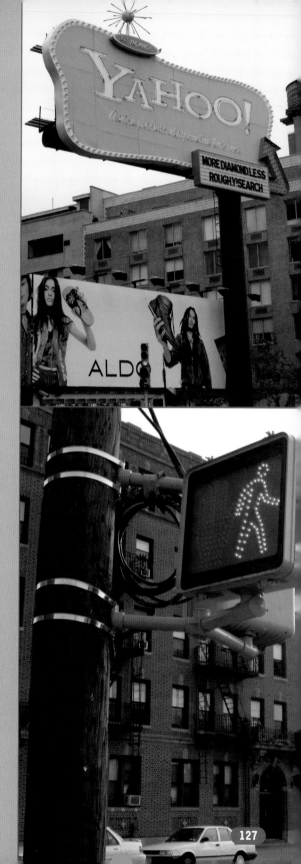

HEY! I'M WALKIN' HERE! You really ought not cut off a New Yorker when walking down the streets ... unless you want to incur wrath and obscene gestures. It is the only place where I've seen intrepid pedestrians retaliate *en masse* when a cab has gotten out of line. It's a "get-out-of-my-way-or-taste-the-sole-of-my-shoe" type of city. Even for natives, it can be a challenge to keep your cool. Upon arrival back in the city to begin the shoot for this book, I caught a cab at the airport. I wasn't back in the city for more than 30 minutes before I got into a full-on shout-out with the driver, who didn't know the way, nearly killed us several times, and still wanted a tip from me on top of the full fare, as I escaped into the middle of traffic. Our "discussion" was arbitrated by a cop who heard us from down the block. It was then that I knew I was home. Obliged to get on the subway still a ways from home, I encountered a long line snaking its way from the token booth. And, sure enough, there was another "discussion" happening. (This one didn't involve me, I swear!) Moral of the story: you've got to be ready when you're in New York. "Ready for what" is fodder for paranoia but also feeds the excitement that gives everyone a continual rush. Anything can happen at any time. Better keep your eyes open. But that is not to imply that everything unexpected is bad. You're just as likely to have a fantastic, spontaneous conversation with someone else waiting in line (as I did that day). Or you can bump into one of the countless celebrities living large in the city. But big-time movie star or not, they'll need to get out of your way if you're in a rush. Democracy reigns supreme in this classless world of get there and get it done! So it is with the graphics of the city, which crowd and jostle their way into your line of sight. Fierce competition and endless variety—one never knows what to expect!

ACKNOWLEDGMENTS The preparation of this volume would not have been possible without the gracious collaboration of our dedicated publisher Aidan Walker. Also at RotoVision, we'd like to thank Erica Ffrench, who provided invaluable editorial input in the book's first stage of formation. Lindy Dunlop also helped us to put our text in order, and April McCroskie shepherded this volume to completion. And RotoVision's Art Director, Luke Herriott, who helped us be confident with our layouts. Our directress of production, Rico Komanoya, made an otherwise insurmountable coordination of material possible and efficient.

Next, there were several individuals whose assistance helped iron out so many of the technical difficulties that cropped up along the way, or provided encouragement: J. Walter Hawkes, Merideth Harte and the lovely ladies at 27.12 design, Cynthia and Hiroshi Kagoshima, Wendy Byrne, Aida Vartanian, the extended Martin family, S. Kwon, Valerie Koehn, Eric A. Clauson, Kyoko Wada, Suzannah Tartan, Caleb Hunt, Raphael Hunt, Todd Londagin, Jon Lesser, John Ceperano and Kim Field, and to everyone else who pointed out a sign or a graffito, offered their help, or patiently listened and looked at our work in progress. Thanks especially to the unknown and unsung artists, graphic designers, sign painters, et cetera, et cetera, whose work is included anonymously and *in situ*, as it was originally placed, and how it was intended to be experienced.